THE BLESSINGS OF FRIENDSHIP

In the sweetness of friendship,
let there be laughing
and the sharing of pleasures.
—Kahlil Gibran

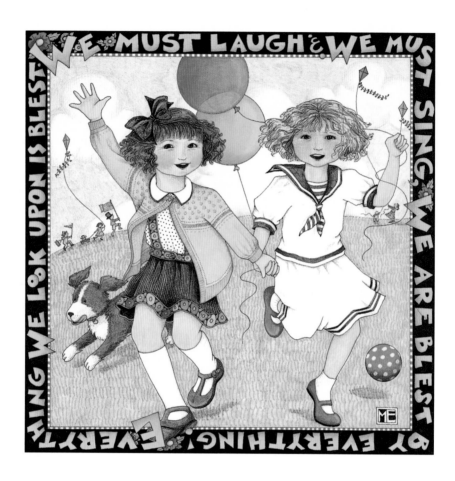

I'd like to be the sort of friend that you have been to me;
I'd like to be the help that you've been always glad to be;
I'd like to mean as much to you each minute of the day,
as you have meant, old friend of mine, to me along the way.

—Edgar A. Guest

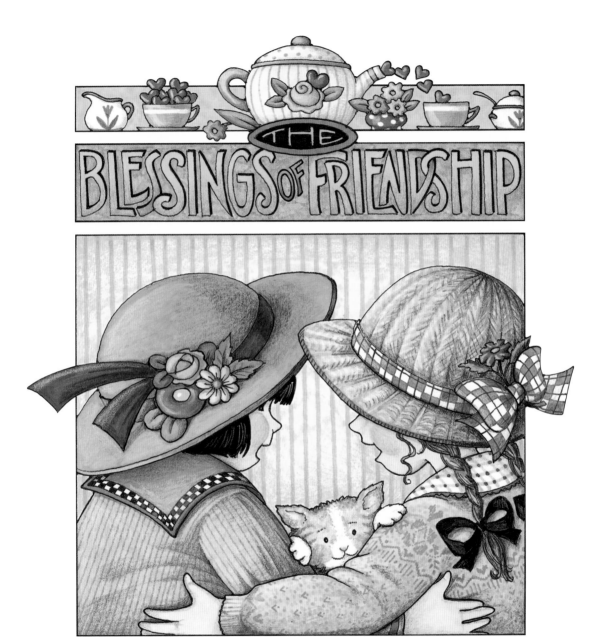

THE BLESSINGS OF FRIENDSHIP

Illustrated by Mary Engelbreit

Andrews McMeel
Publishing

Kansas City

www.andrewsmcmeel.com
www.maryengelbreit.com

and Mary Engelbreit are registered trademarks of Mary Engelbreit Enterprises, Inc.

02 03 04 05 06 MON 10 9 8 7 6 5 4 3 2 1

Library of Congress Cataloging-in-Publication Data

The blessings of friendship : a friendship treasury / [compiled and] illustrated by
Mary Engelbreit.
 p. cm.
 Includes indexes.
 ISBN 0-7407-2366-9
 1. Friendship—Quotations, maxims, etc. I. Engelbreit, Mary.

PN6084.F8 B59 2002
177'.62—dc21 2002023207

ATTENTION SCHOOLS AND BUSINESSES

Andrews McMeel books are available at quantity discounts with bulk purchase for educational,
business or sales promotional use. For information, please write to Special Sales Department,
Andrews McMeel Publishing, 4520 Main Street, Kansas City, Missouri 64111.

Contents

FRIENDS ❤ FOREVER

FRIENDS ♥ FOREVER

FRIENDS ♥ FOREVER

 # ILLUSTRATIONS

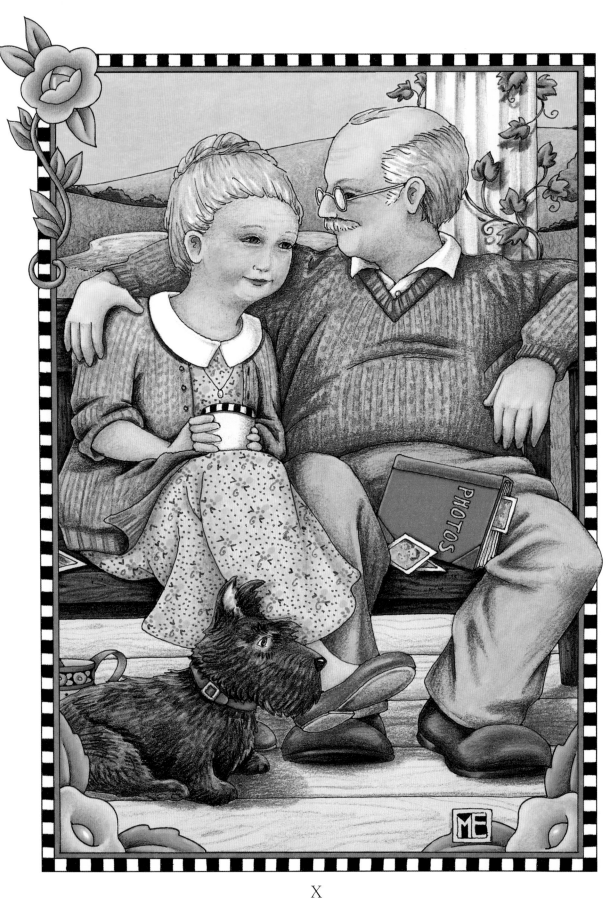

No Time Like the Old Time

Oliver Wendell Holmes

There is no time like the old time,
when you and I were young,
When the buds of April blossomed,
and the birds of spring-time sung!
The garden's brightest glories
by summer suns are nursed,
But oh, the sweet, sweet violets,
the flowers that opened first!

There is no friend like an old friend,
who has shared our morning days,
No greeting like his welcome,
no homage like his praise.
Fame is the scentless sunflower,
with gaudy crown of gold;
But friendship is the breathing rose,
with sweets in every fold.

For DEB
AND
all my pals

Introduction

For me, friendship has always been a long-term proposition. Friends do not come and go. They come slowly and stay.

True friendships are life-long affairs, and I've been lucky to have more than my share. In fact, many of my closest friends today were filling that same role 20, 30, some even 40 years ago.

All of these friends know how much I love to read. And it's also no secret that I'm often inspired by the words of those authors I love—especially when the words concern friendship.

There are so many facets to friendship—excitement, trust, compassion, forgiveness, and sheer joy among them—and so many ways to express all of these feelings, that I know friendship will always be a fertile source of inspiration for my art. In fact, I've often said that without friends to fill my life, I would have had no life to fill my art.

This book unites these two great inspirations: good writing and true friendship. In it, I've collected excerpts from novels, poems, songs, and even from some extraordinary letters—all of which capture in powerful words the supreme joy of friendship. I like the idea of the literary excerpts in this book being presented side-by-side with my art, because, in my mind, these words surround, inspire, and perfectly complement the images that I draw.

Friendship, like good writing, is truly an art. I hope you enjoy this tribute to friendship through words and images, and I hope that, like a true friendship, this book will be a source of joy that will last a lifetime.

Mary Engelbreit

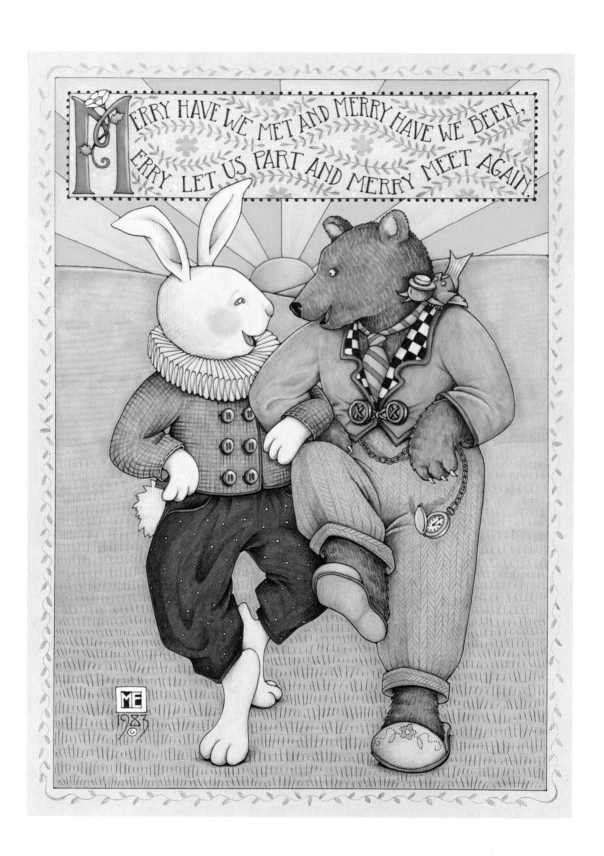

MERRY HAVE WE MET AND MERRY HAVE WE BEEN, MERRY LET US PART AND MERRY MEET AGAIN.

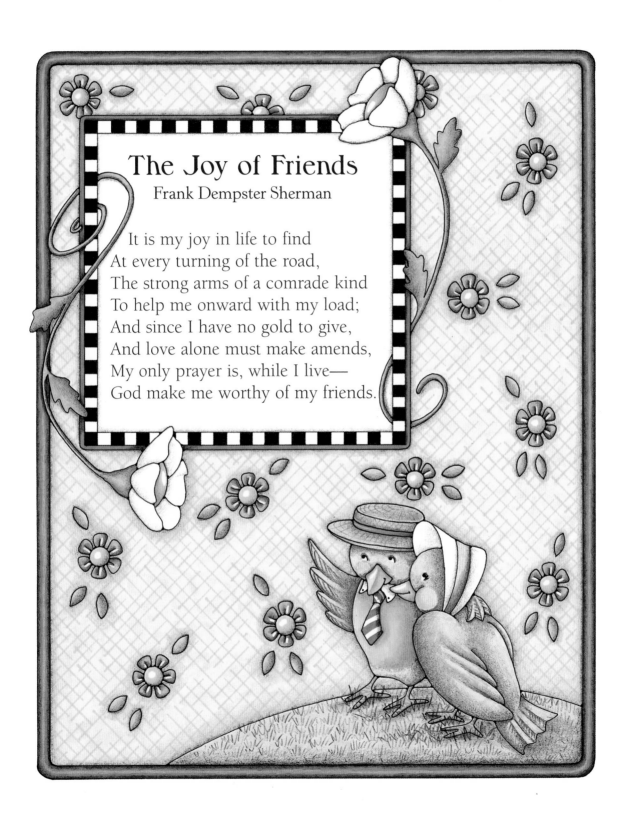

The Joy of Friends

Frank Dempster Sherman

It is my joy in life to find
At every turning of the road,
The strong arms of a comrade kind
To help me onward with my load;
And since I have no gold to give,
And love alone must make amends,
My only prayer is, while I live—
God make me worthy of my friends.

All You Need Is a Friend

Jan Miller Girando

When a sunny hello would help brighten your day...
When you've just heard good news and have volumes to say...
When two tickets turn up to a great matinee...
...all you need is a friend!

When the path that you're on turns surprisingly rough...
When wherever you're going, the going gets tough...
When you're giving your all but it's just not enough...
...all you need is a friend!

A friend speaks the truth when it needs to be told...
Tells you you're radiant when you feel old...
Gives you a nudge when you must be cajoled...
Likes you as you are...

Joins in your mischief with vigor and zest...
Makes you aware that you're looking your best...
Leaves you alone if you just need a rest...
But never strays too far.

When a role model's needed to keep you on track...
When you've tried to be open but don't have the knack...
When you've earned a good word and a pat on the back...
...all you need is a friend.

When it's shared, every day can be even more fun...
And a duo is often much better than one...
So remember each dawn as you rise with the sun...
All you need is a friend!

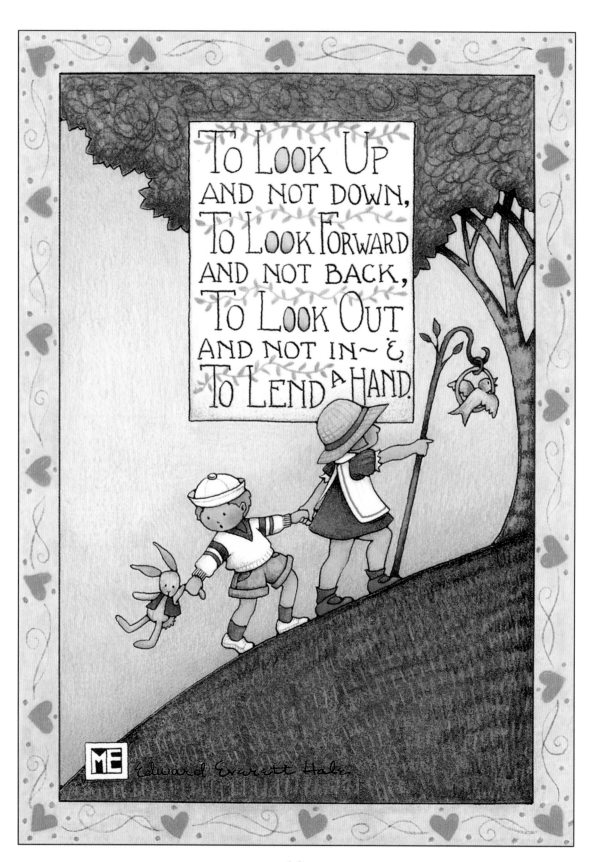

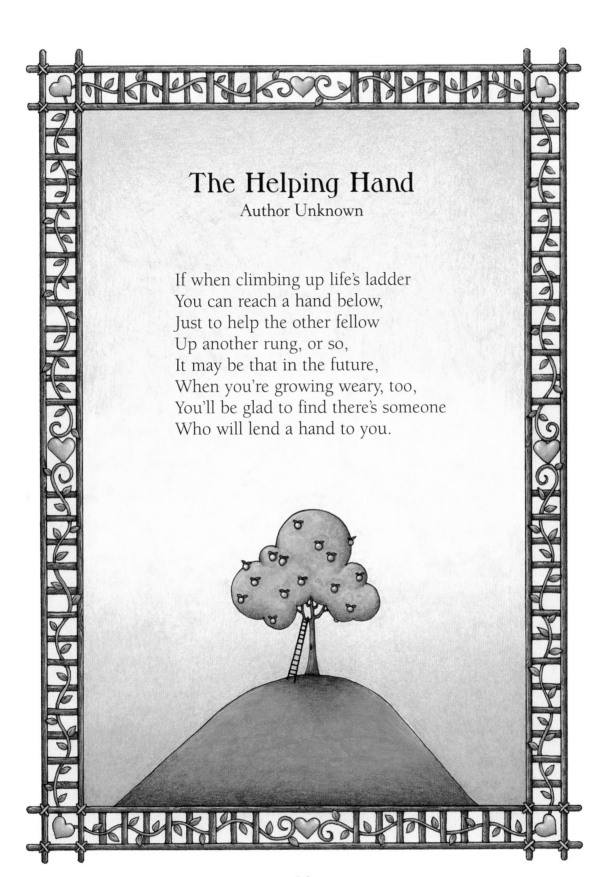

The Helping Hand
Author Unknown

If when climbing up life's ladder
You can reach a hand below,
Just to help the other fellow
Up another rung, or so,
It may be that in the future,
When you're growing weary, too,
You'll be glad to find there's someone
Who will lend a hand to you.

Old friends are best.
King James used to call for his old shoes;
they were easiest for his feet.

—John Selden

It is easy to say how we love new friends,
and what we think of them,
but words can never trace out
all the fibers that knit us to the old.

—George Eliot

To conceal anything from
those to whom I am attached,
is not in my nature.
I can never close my lips
where I have opened my heart.

—Charles Dickens

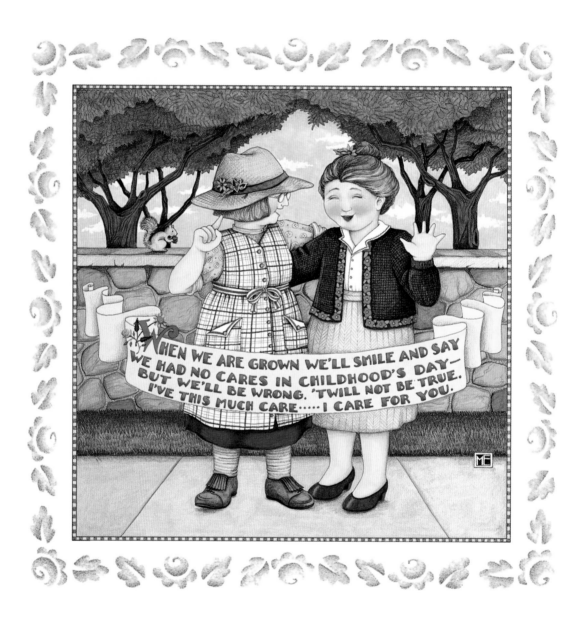

When we are grown we'll smile and say
we had no cares in childhood's day—
but we'll be wrong. 'Twill not be true.
I've this much care.....I care for you.

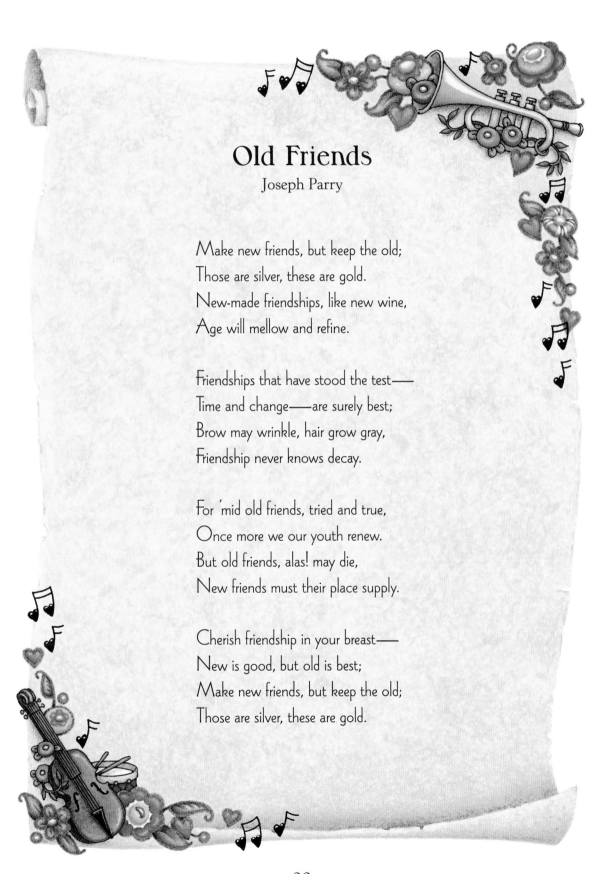

Old Friends

Joseph Parry

Make new friends, but keep the old;
Those are silver, these are gold.
New-made friendships, like new wine,
Age will mellow and refine.

Friendships that have stood the test—
Time and change—are surely best;
Brow may wrinkle, hair grow gray,
Friendship never knows decay.

For 'mid old friends, tried and true,
Once more we our youth renew.
But old friends, alas! may die,
New friends must their place supply.

Cherish friendship in your breast—
New is good, but old is best;
Make new friends, but keep the old;
Those are silver, these are gold.

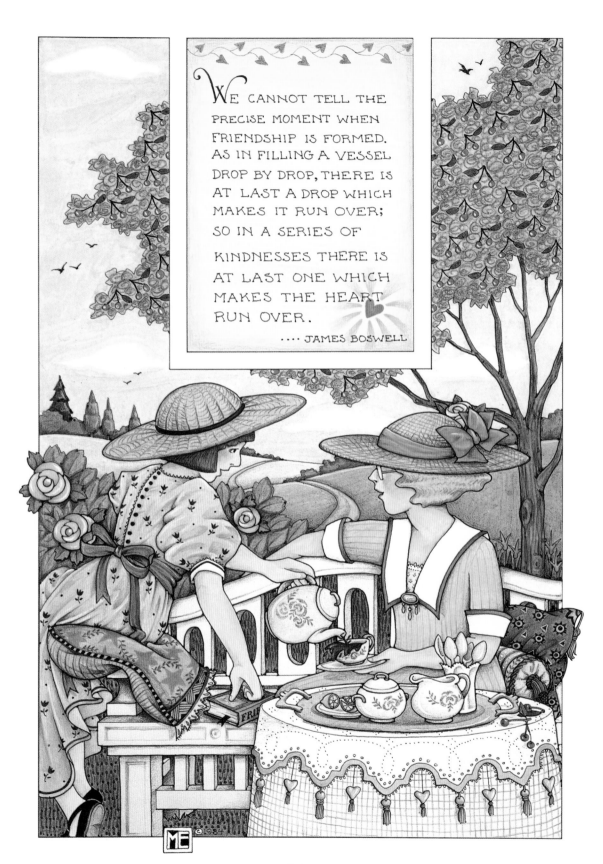

WE CANNOT TELL THE PRECISE MOMENT WHEN FRIENDSHIP IS FORMED. AS IN FILLING A VESSEL DROP BY DROP, THERE IS AT LAST A DROP WHICH MAKES IT RUN OVER; SO IN A SERIES OF KINDNESSES THERE IS AT LAST ONE WHICH MAKES THE HEART RUN OVER.

.... JAMES BOSWELL

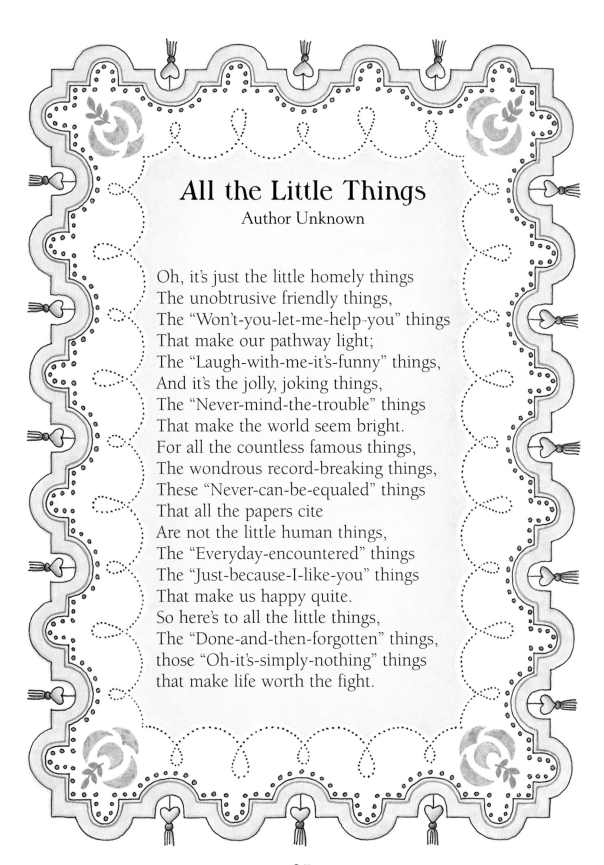

All the Little Things
Author Unknown

Oh, it's just the little homely things
The unobtrusive friendly things,
The "Won't-you-let-me-help-you" things
That make our pathway light;
The "Laugh-with-me-it's-funny" things,
And it's the jolly, joking things,
The "Never-mind-the-trouble" things
That make the world seem bright.
For all the countless famous things,
The wondrous record-breaking things,
These "Never-can-be-equaled" things
That all the papers cite
Are not the little human things,
The "Everyday-encountered" things
The "Just-because-I-like-you" things
That make us happy quite.
So here's to all the little things,
The "Done-and-then-forgotten" things,
those "Oh-it's-simply-nothing" things
that make life worth the fight.

Reunion

Anna Quindlen

Robert called me "baby" just recently. "Same old Robert," Donna said. The only difference was that the last time he said it I was thirteen years old and unsure whether I was supposed to be amused, offended, or flattered. He was my best boyfriend, with the emphasis on the friend. We spent hours on the phone together each night deciding which girl deserved his tie clip. I still know the telephone number at his mother's house by heart.

I went to the twentieth reunion of my eighth grade class the other night. It was nearly a five-hour drive, there and back. Some people I know thought I was a little crazy: high school, maybe, or college, but grade school? Perhaps they went to a different kind of school.

A couple of dozen of us started out together when we were small children, and stayed together until we were just entering adolescence. Those were the people with whom I learned the alphabet and the Our Father, how to shoot from the foul line and do a cartwheel. Those were some of the most important years of my life. We know now how important the early years are, but the early years lasted longer then, and while the bedrock on which I am built came from my family, many of my first lessons in friendship, loss, loyalty, and love came from a group of people I have not seen for two decades. They have always seemed somehow more real to me than most of the people I have known since.

2x2=4 2x3=6 2x4=8 x5=10

It was odd, how much the same we all looked. It would have been hard for the women to look worse, or at least worse than our graduation picture, with all of us grouped on the lawn by the convent. Most of us look younger now than we did there, our poor hair lacquered into beehives or baloney curls, our feet squeezed into pumps with pointed toes.

And it was odd how much the same we were, odd how early the raw material had been set. Robert was still the class flirt, Janet still elegant. "Refined" was how I described her in a sixth-grade composition—a funny word for an eleven-year-old girl, and yet the right one, particularly now that it suited her so. In the photograph, Donna and I are next to each other, trying not to crack up. "Still inseparable," said Jeff, the class president, looking down at the two of us giggling on the steps. The truth was that although we had not met for fifteen years, the ice was broken within minutes.

I'm not sure that I would have done well at a tenth reunion. If the raw material is laid down in those first thirteen years, the next thirteen sometimes seem to me to have been given over fruitlessly to the art of artifice, the attempt to hide the flaws beneath a construction as false as those 1966 beehives. Now I am much more who I am, with fewer regrets, apologies, and attempts to be something else. To be honest, I am much more like 1966 than I would have been likely to admit ten years ago. Perhaps it was the beer, but some of the others seemed to be letting down their defenses, too.

Ed remembered that when he had had to think of his most embarrassing moment for a Dale Carnegie course, it was something that had happened in elementary school. ("You're not going to put it in?" he asked plaintively, a lifetime after it happened, and so I said I would not.) And Jim, the host of the party, suddenly said as he saw Robert and me trading wisecracks, "You guys and your clique," making me think, for the first time,

really of how thoughtlessly hurtful we were then, too. I suppose in a way it was like many reunions. We talked about the time we Crazy-Foamed the gym, went on class picnics to Naylor's Run and dared to go to the public-school canteen. There were children to discuss, and deaths and divorces. Most of the men still lived in the area. Most of the women had moved away. Most of the men came with their wives. Most of the women came alone.

And yet I felt that it was a different kind of occasion, at least for me. Steve had brought photographs from class trips and parties, and in one of them there I was in the front in a plaid dress, my bangs cut too short, my new front teeth a little too big for my face, and it was like looking at one of those photographs of an embryo. On Jim's back porch I looked around and I saw so many prototypes: my first close friendship, my first jealousies, my first boyfriend—all the things that break you in for all the things that are yet to come. I felt like Emily in *Our Town*.

Robert and I talked a lot about Martha. It turned out that over the years he had never forgotten her. He was crushed that she had not been able to come up from Florida where she is a teacher. Besides, he said, she still has his tie clip. But it wasn't really Martha he was talking about as much as a basic model he learned then. He liked her and she liked him. It was only later that he, I, and all the rest of us learned that is the basic model, but it sometimes comes with fins and a sunroof, with games and insecurities and baggage that are just barely burgeoning when you are thirteen years old.

On the stereo was a song, a 45, that we must have played thousands of times in my living room: "She Loves You" by the Beatles. "With a love like that, you know you should be glad." Robert played the drums. I sang. He made a grab for me, and I slipped past him. "Same old Robert," I said to Donna.

Friendship never forgets.

That is the wonderful thing about it.

~Oscar Wilde

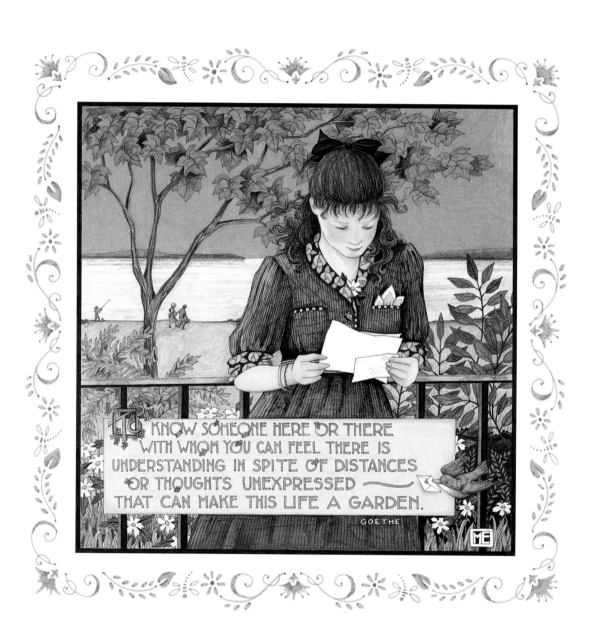

TO KNOW SOMEONE HERE OR THERE
WITH WHOM YOU CAN FEEL THERE IS
UNDERSTANDING IN SPITE OF DISTANCES
OR THOUGHTS UNEXPRESSED —
THAT CAN MAKE THIS LIFE A GARDEN.

GOETHE

32

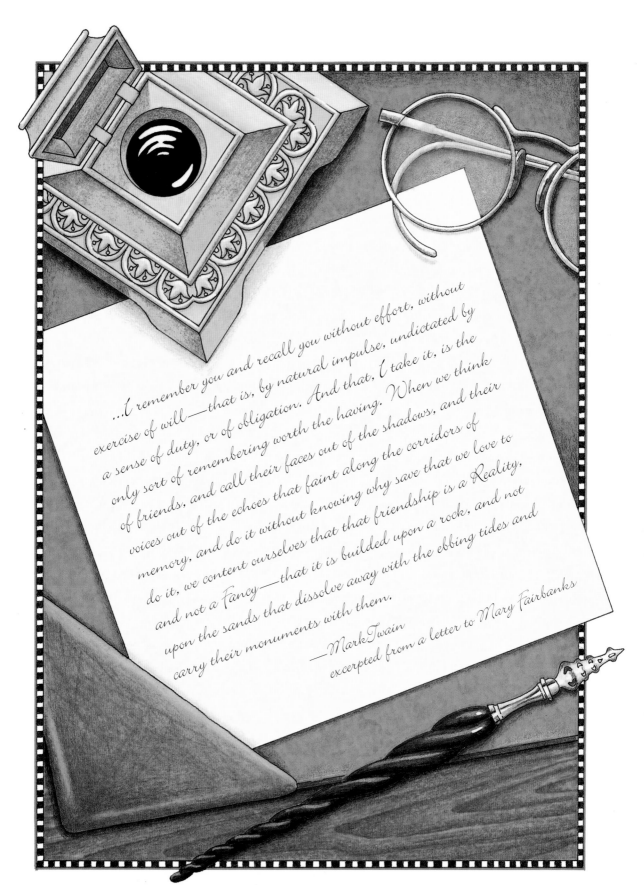

...I remember you and recall you without effort, without exercise of will—that is, by natural impulse, undictated by a sense of duty, or of obligation. And that, I take it, is the only sort of remembering worth the having. When we think of friends, and call their faces out of the shadows, and their voices out of the echoes that faint along the corridors of memory, and do it without knowing why save that we love to do it, we content ourselves that that friendship is a Reality, and not a Fancy—that it is builded upon a rock, and not upon the sands that dissolve away with the ebbing tides and carry their monuments with them.

—Mark Twain
excerpted from a letter to Mary Fairbanks

Friends

Elton John and Bernie Taupin

I hope the day will be a brighter highway,
for friends are found on every road.
Can you ever think of any better way
for the lost and weary traveler to go?

Chorus:
Making friends for the world to see,
let the people know you got what you need.
With a friend at hand
you will see the light,
if your friends are there
then everything's all right.
It seems to me a crime that we should age,
these fragile times should never slip us by.
A time you never can or shall erase
as friends together watch their childhood fly.

repeat chorus

KEEP SHINING, MY BRIGHT & SHINING STAR OF A FRIEND....

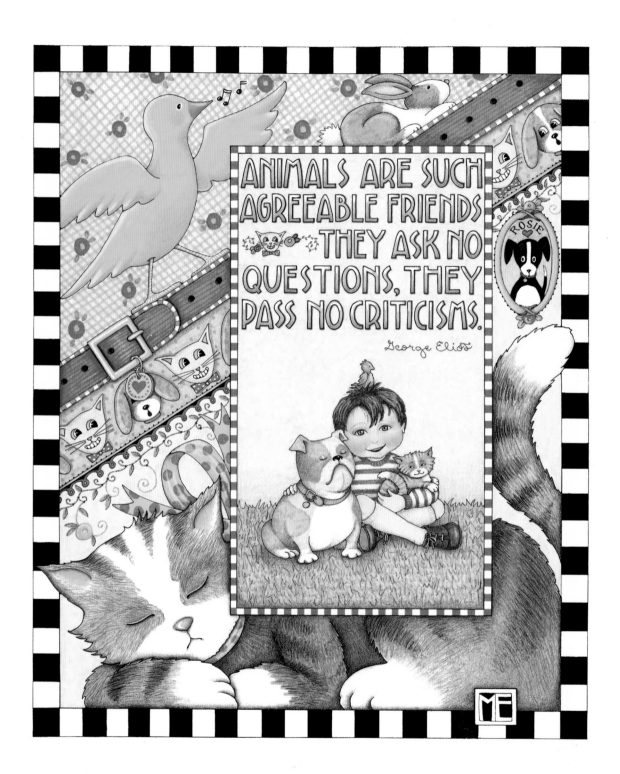

ANIMALS ARE SUCH AGREEABLE FRIENDS THEY ASK NO QUESTIONS, THEY PASS NO CRITICISMS.

George Eliot

ROSIE

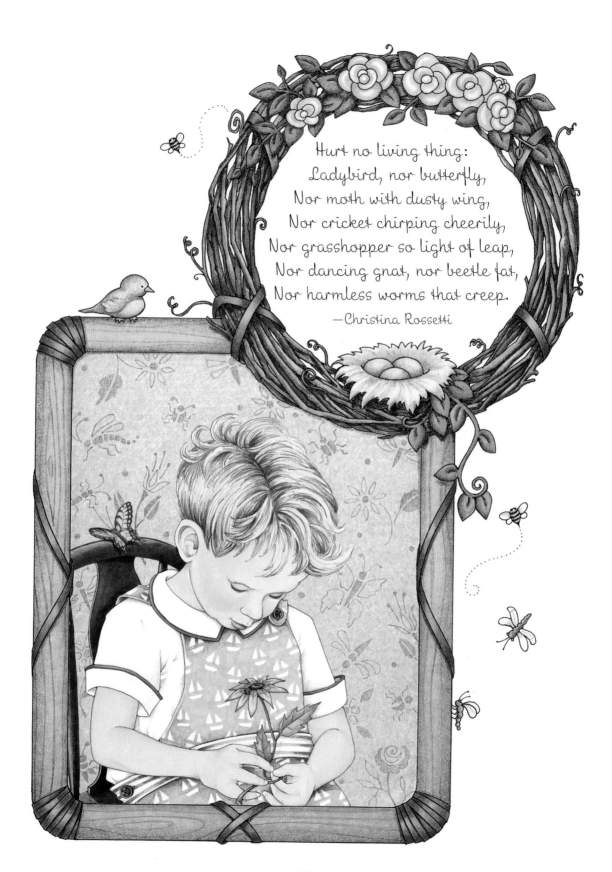

Hurt no living thing:
Ladybird, nor butterfly,
Nor moth with dusty wing,
Nor cricket chirping cheerily,
Nor grasshopper so light of leap,
Nor dancing gnat, nor beetle fat,
Nor harmless worms that creep.

—Christina Rossetti

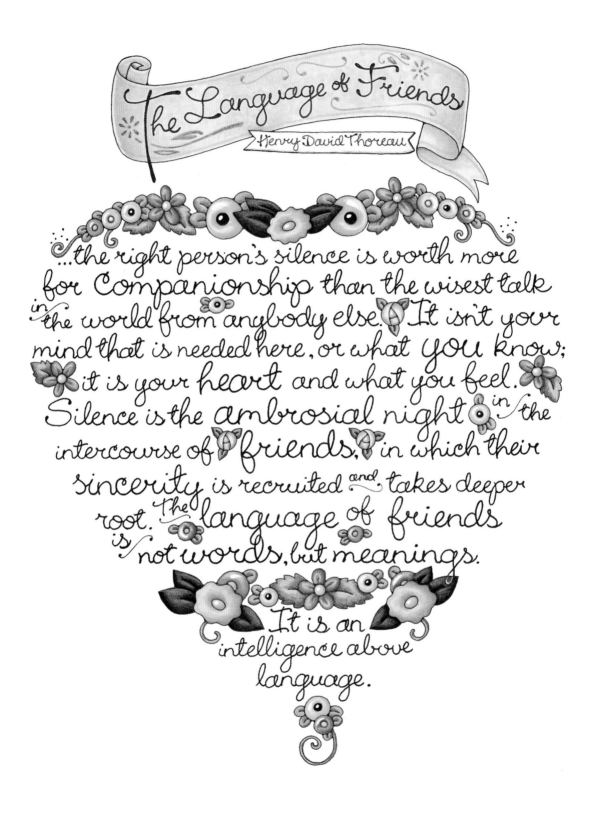

The Language of Friends

Henry David Thoreau

...the right person's silence is worth more for Companionship than the wisest talk in the world from anybody else. It isn't your mind that is needed here, or what YOU know; it is your heart and what you feel. Silence is the ambrosial night in the intercourse of friends, in which their sincerity is recruited and takes deeper root. The language of friends is not words, but meanings. It is an intelligence above language.

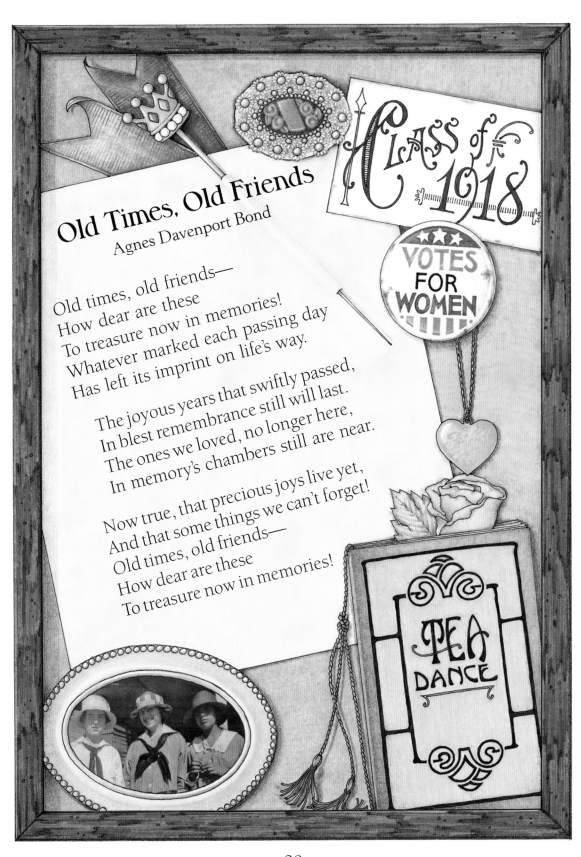

Old Times, Old Friends
Agnes Davenport Bond

Old times, old friends—
How dear are these
To treasure now in memories!
Whatever marked each passing day
Has left its imprint on life's way.

The joyous years that swiftly passed,
In blest remembrance still will last.
The ones we loved, no longer here,
In memory's chambers still are near.

Now true, that precious joys live yet,
And that some things we can't forget!
Old times, old friends—
How dear are these
To treasure now in memories!

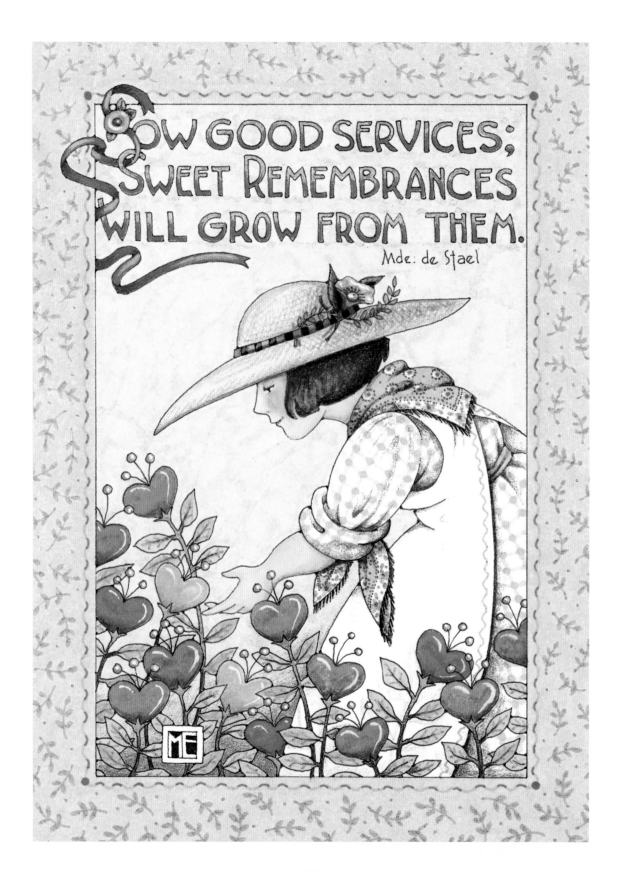

SOW GOOD SERVICES;
SWEET REMEMBRANCES
WILL GROW FROM THEM.

Mde: de Stael

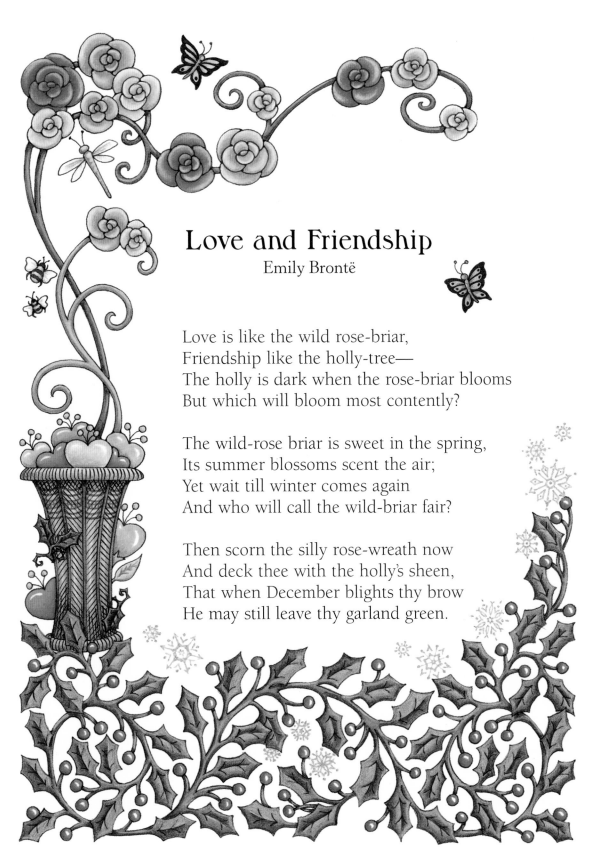

Love and Friendship

Emily Brontë

Love is like the wild rose-briar,
Friendship like the holly-tree—
The holly is dark when the rose-briar blooms
But which will bloom most contently?

The wild-rose briar is sweet in the spring,
Its summer blossoms scent the air;
Yet wait till winter comes again
And who will call the wild-briar fair?

Then scorn the silly rose-wreath now
And deck thee with the holly's sheen,
That when December blights thy brow
He may still leave thy garland green.

As I love nature, as I love singing birds,
and gleaming stubble, and flowing rivers,
and morning and evening, and summer and winter,
I love thee my friend.
—Henry David Thoreau

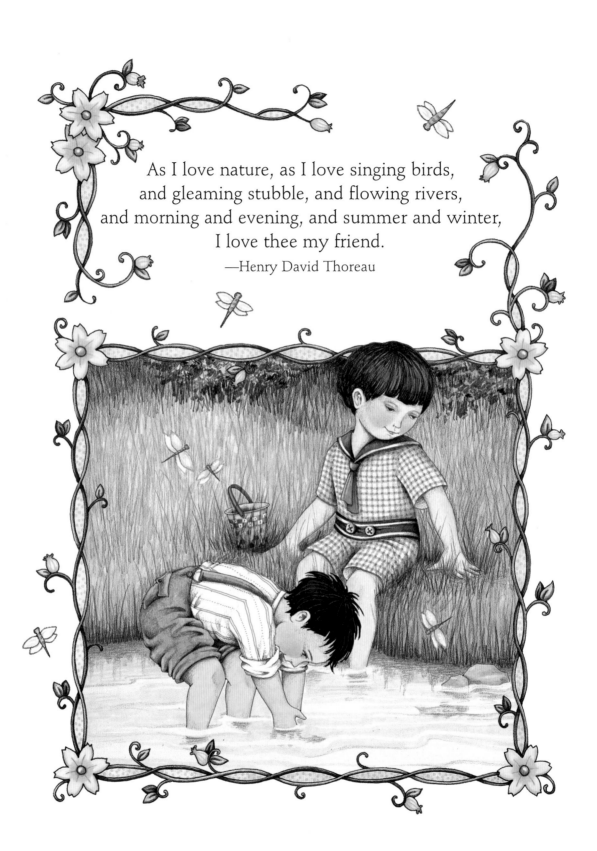

Our friendship was so assured
that we could be silent
without the slightest danger of offense.
—Sir Arthur Helps

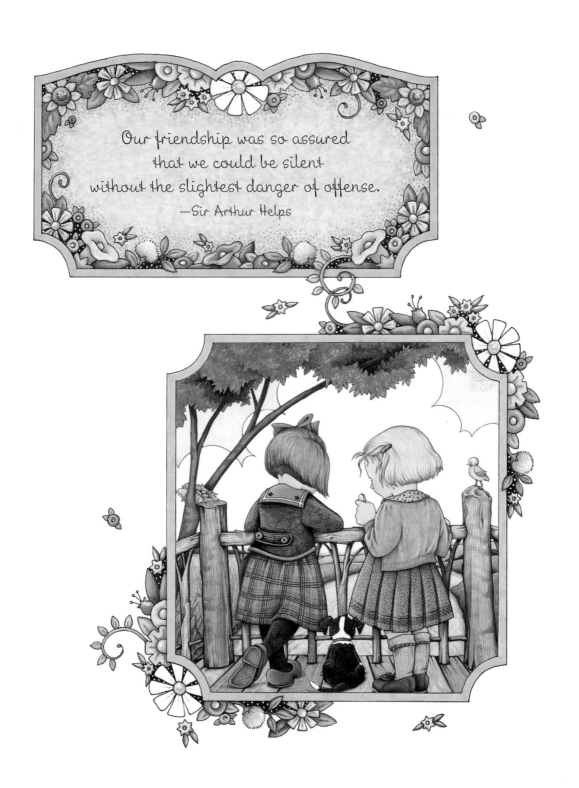

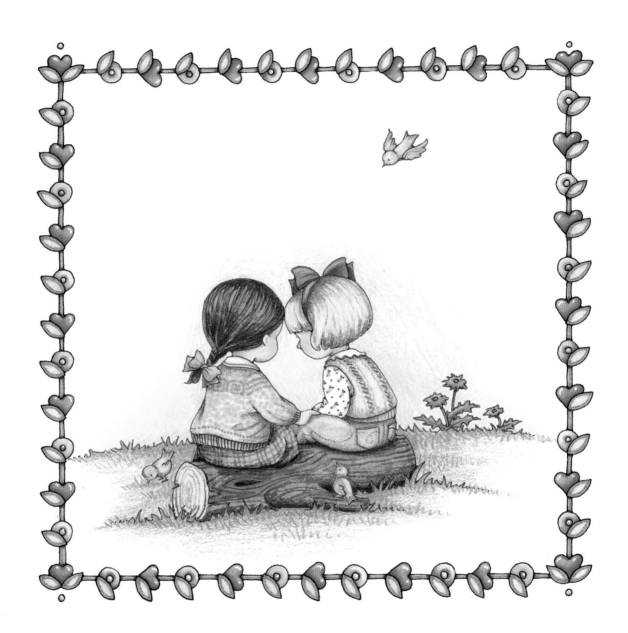

This Is Friendship

Mary Carolyn Davies

I love you, not only for what you are,
but for what I am when I am with you.
I love you, not only for what you have made of yourself,
but for what you are making of me.
I love you for the part of me that you bring out.
I love you for putting your hand into my heaped-up heart
and passing over all the frivolous and weak things
 that you cannot help seeing there,
and drawing out into the light all the beautiful, radiant things
 that no one else has looked quite far enough to find.
I love you for ignoring the possibilities of the fool in me
and for laying firm hold of the possibilities of good in me.
I love you for closing your eyes to the discords in me,
and adding to the music in me by worshipful listening.
I love you because you are helping me make
of the lumber of my life, not a tavern, but a temple,
and of the words of my days, not a reproach, but a song.
I love you because you have done more
 than any creed could have done to make me happy.
You have done it without a touch, without a word, without a sign.
You have done it by being yourself.
After all, perhaps this is what being a friend means.

Getting to Know You

from *The King and I*,
music and lyrics by Rodgers and Hammerstein

It's a very ancient saying
But a true and honest thought
That if you become a teacher
By your pupils you'll be taught
As a teacher I've been learning
You'll forgive me if I boast
And I've now become an expert
On the subject I like most
Getting to know you!

Getting to know you,
Getting to feel free and easy.
When I am with you,
Getting to know what to say.
Haven't you noticed,
Suddenly I'm bright and breezy,
Because of all the beautiful and new
Things I'm learning about you
Day by day!

Getting to know you,
Getting to know all about you.
Getting to like you,
Getting to hope you like me.
Getting to know you
Putting it my way but nicely.
You are precisely,
my cup of tea.

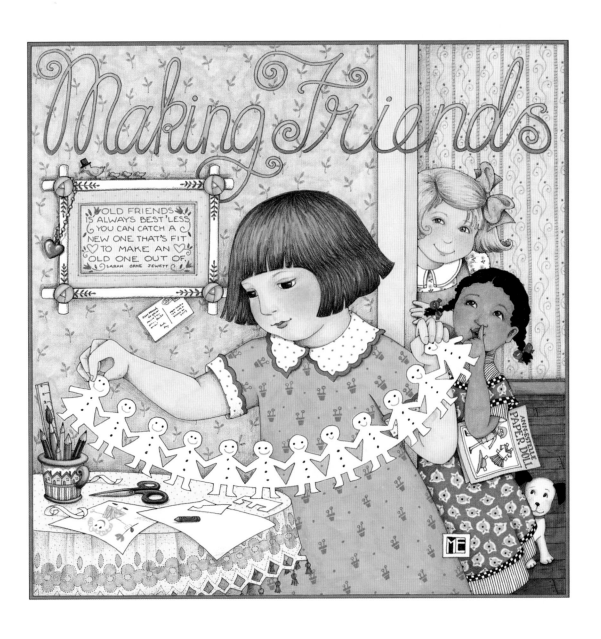

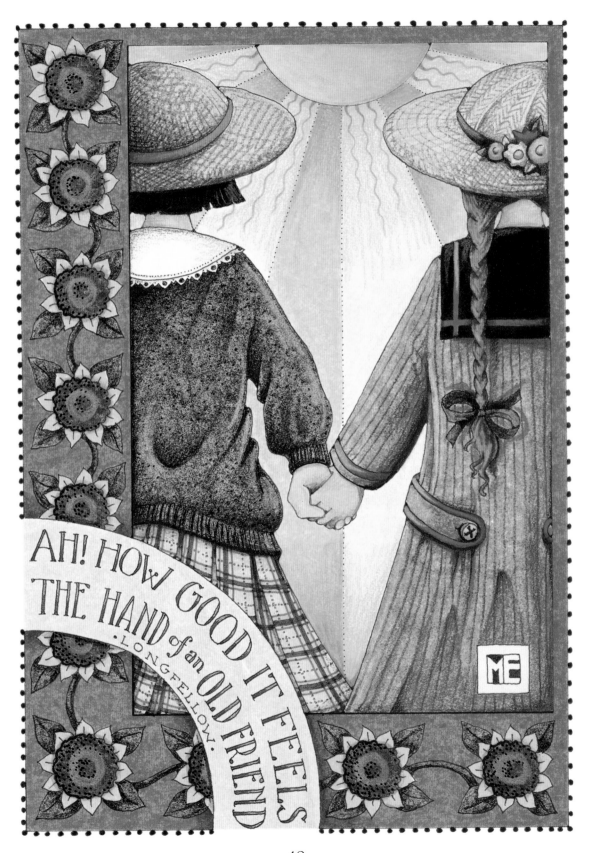

AH! HOW GOOD IT FEELS THE HAND of an OLD FRIEND · LONGFELLOW ·

48

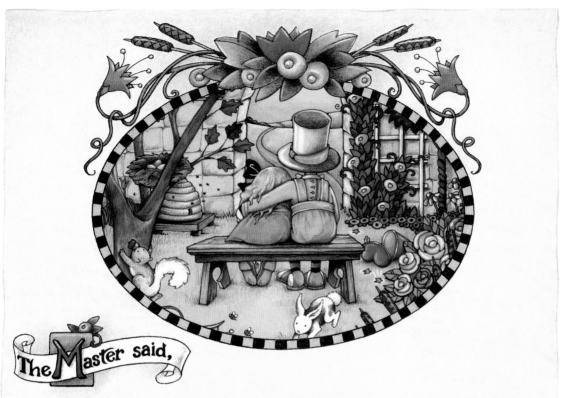

The Master said,

"Life leads the thoughtful man on a path of many windings.
Now the course is checked, now it runs straight again.
Here winged thoughts may pour freely forth in words,
There the heavy burden of knowledge must be shut away in silence.
But when two people are at one in their inmost hearts,
They shatter even the strength of iron or of bronze.
And when two people understand each other in their inmost hearts,
Their words are sweet and strong, like the fragrance of orchids."

—Excerpt from the *I Ching*

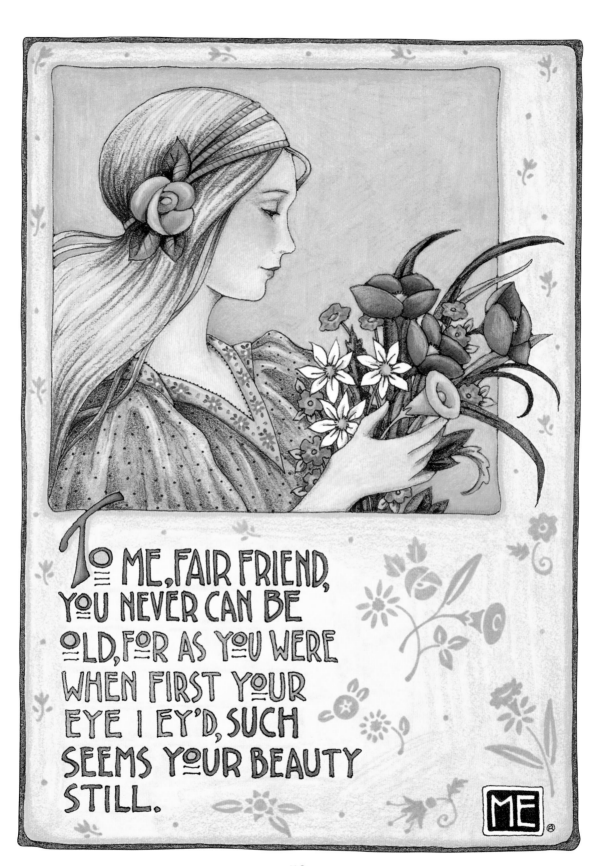

To me, fair friend,
you never can be
old, for as you were
when first your
eye I ey'd, such
seems your beauty
still.

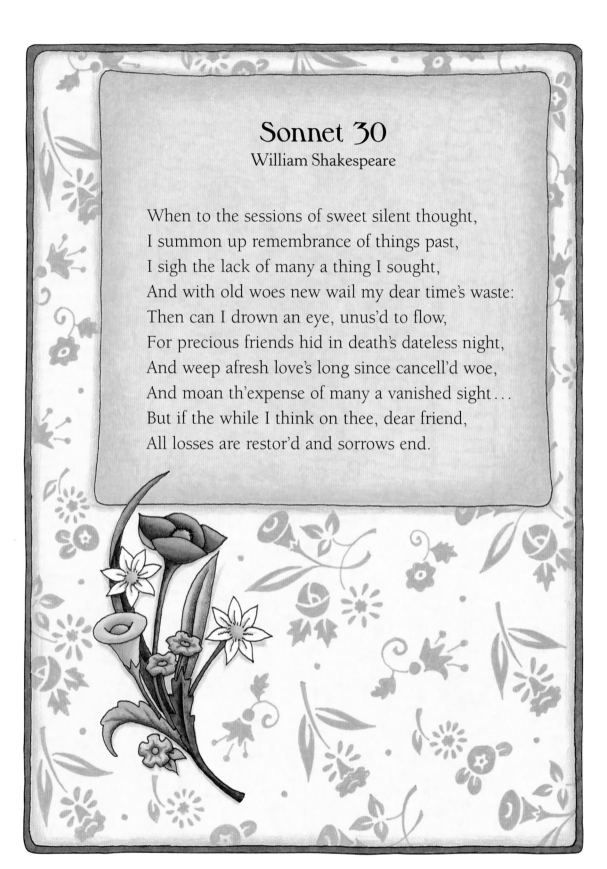

Sonnet 30

William Shakespeare

When to the sessions of sweet silent thought,
I summon up remembrance of things past,
I sigh the lack of many a thing I sought,
And with old woes new wail my dear time's waste:
Then can I drown an eye, unus'd to flow,
For precious friends hid in death's dateless night,
And weep afresh love's long since cancell'd woe,
And moan th'expense of many a vanished sight…
But if the while I think on thee, dear friend,
All losses are restor'd and sorrows end.

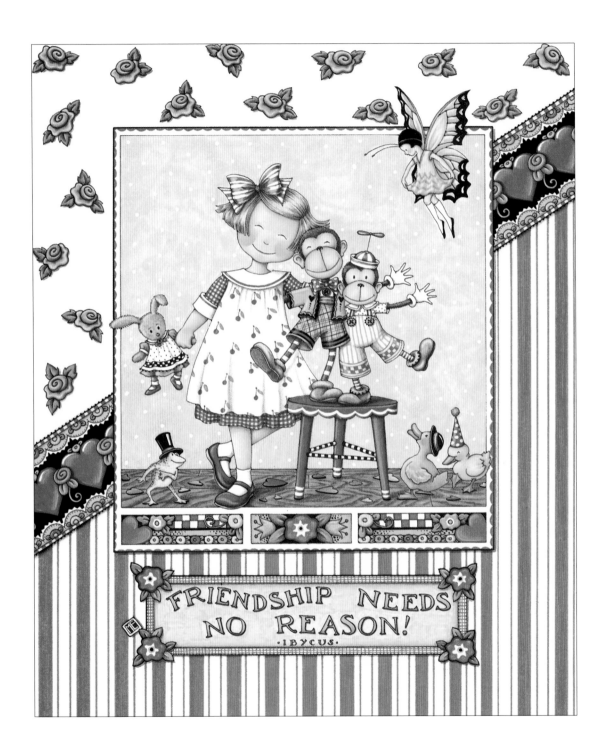

FRIENDSHIP NEEDS NO REASON!
·IBYCUS·

Smile

Author Unknown

A smile costs nothing, but gives so much. It enriches those who receive, without making poorer those who give. It takes but a moment, but the memory of it sometimes lasts forever. None is so rich or mighty that he gets along without it and none is so poor but that he can be made rich by it. A smile creates happiness in the home, fosters good will in business and is the countersign of friendship. It brings rest to the weary, cheer to the discouraged, sunshine to the sad, and is nature's best antidote for trouble. Yet it cannot be bought, begged, borrowed or stolen for it is something that is of no value to anyone until it is given away. Some people are too tired to give you a smile; give them one of yours, as none needs a smile so much as he who has no more to give.

Friendship? Yes Please.

—Charles Dickens

The Morning Walk

A. A. Milne

When Anne and I go out to walk,
We hold each other's hand and talk
Of all the things we mean to do
When Anne and I are forty-two.

And when we've thought about a thing,
Like bowling hoops or bicycling,
Or falling down on Anne's balloon,
We do it in the afternoon.

You're the Top

Words and music by Cole Porter,
from the 1934 musical *Anything Goes*

At words poetic, I'm so pathetic
That I always have found it best,
Instead of getting 'em off my chest,
To let 'em rest unexpressed.
I hate parading
My serenading
As I'll probably miss a bar,
But if this ditty is not so pretty,
At least it'll tell you how great you are.

You're the top!
You're the Colosseum,
You're the top!
You're the Louvre Museum.
You're a melody from a symphony by Strauss,
You're a Bendel bonnet,
A Shakespeare sonnet,
You're Mickey Mouse.
You're the Nile, you're the Tow'r of Pisa,
You're the smile on the Mona Lisa.
I'm a worthless check, a total wreck, a flop,
But if, baby, I'm the bottom, you're the top.

You're the top!
You're Mahatma Ghandi.
You're the top!
You're Napolean brandy.
You're the purple light of a summer night in Spain,
You're the National Gall'ry,
You're Garbo's sal'ry,
You're cellophane.
You're sublime,
You're a turkey dinner.
You're the time of the Derby winner.
I'm a toy balloon that is fated soon to pop.
But if, baby, I'm the bottom, you're the top!

You're the top!
You're an Arrow collar.
You're the top!
You're a Coolidge dollar.
You're the nimble tread of the feet of Fred Astaire,
You're an O'Neill drama,
You're Whistler's mama,
You're Camembert.
You're a rose,
You're Inferno's Dante,
You're the nose on the great Durante.
I'm just in the way, as the French would say "De trop,"
But if, baby, I'm the bottom, you're the top.

You're the top!
You're a Waldorf salad.
You're the top!
You're a Berlin ballad.
You're a baby grand of a lady and a gent.
You're an old dutch master,
You're Mrs. Aster,
You're Pepsodent.
You're romance,
You're the steppes of Russia,
You're the pants on a Roxy usher.
I'm a lazy lout that's just about to stop,
But if, baby, I'm the bottom, you're the top!

You're the top!
You're a dance in Bali.
You're the top!
You're a hot tamale.
You're an angel, you, simply too, too, too diveen,
You're a Botticelli,
You're Keats, you're Shelley,
You're Ovaltine.
You're a boon, you're the dam at Boulder,
You're the moon over Mae West's shoulder.
I'm a nominee of the G.O.P.
or GOP,
But if, baby, I'm the bottom, you're the top!

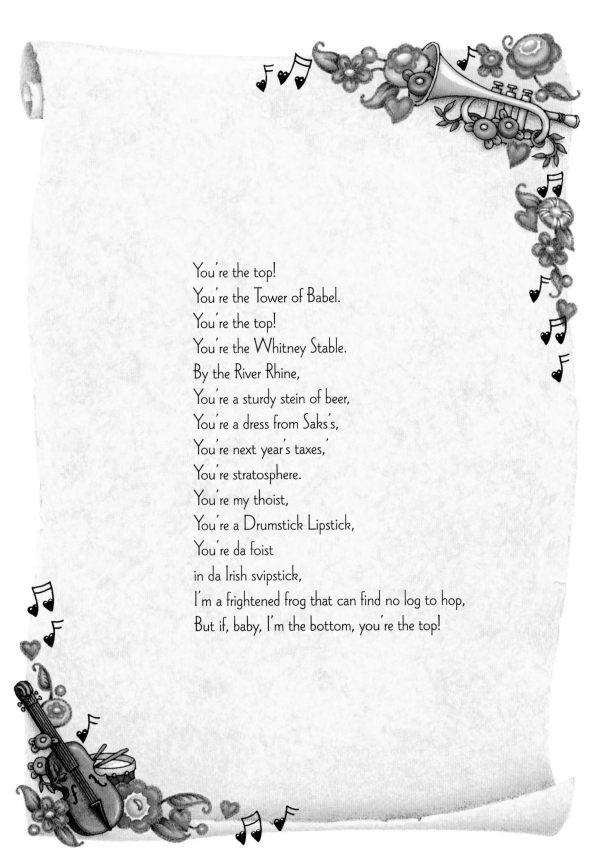

You're the top!
You're the Tower of Babel.
You're the top!
You're the Whitney Stable.
By the River Rhine,
You're a sturdy stein of beer,
You're a dress from Saks's,
You're next year's taxes,'
You're stratosphere.
You're my thoist,
You're a Drumstick Lipstick,
You're da foist
in da Irish svipstick,
I'm a frightened frog that can find no log to hop,
But if, baby, I'm the bottom, you're the top!

ONE TOUCH of NATURE MAKES THE WHOLE WORLD KIN.

SHAKESPEARE

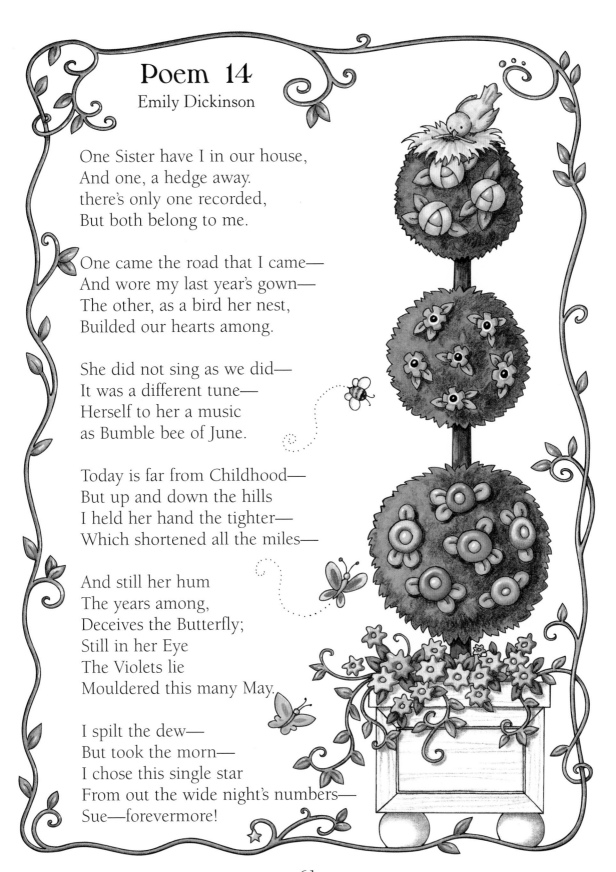

Poem 14

Emily Dickinson

One Sister have I in our house,
And one, a hedge away.
there's only one recorded,
But both belong to me.

One came the road that I came—
And wore my last year's gown—
The other, as a bird her nest,
Builded our hearts among.

She did not sing as we did—
It was a different tune—
Herself to her a music
as Bumble bee of June.

Today is far from Childhood—
But up and down the hills
I held her hand the tighter—
Which shortened all the miles—

And still her hum
The years among,
Deceives the Butterfly;
Still in her Eye
The Violets lie
Mouldered this many May.

I spilt the dew—
But took the morn—
I chose this single star
From out the wide night's numbers—
Sue—forevermore!

There Is No Friend Like a Sister

Jan Miller Girando

There's no better friend than a sister—
There's no one more loyal and true…
…and even when sisters are different…
…their likenesses come shining through!

Perhaps it's a family resemblance
That strengthens the bond that they share…
…or maybe it's just the way sisters
live life with a similar flair!

A sister remembers your childhood—
She knows more than you will admit
Of times you were Little Miss Perfect…
…and times you gave others a fit!

She's seen you in some situations
Where silence just wouldn't suffice...
...and managed somehow to get by with
those sisterly words of advice!

And when some encouragement's needed...
...a sister will always be there...
to listen,
to laugh,
or to lean on,
to comfort,
or simply to care.

There's no one who's more in your corner...
...and no one you're more grateful to.
There's no better friend than a sister...
...and no better sister than you.

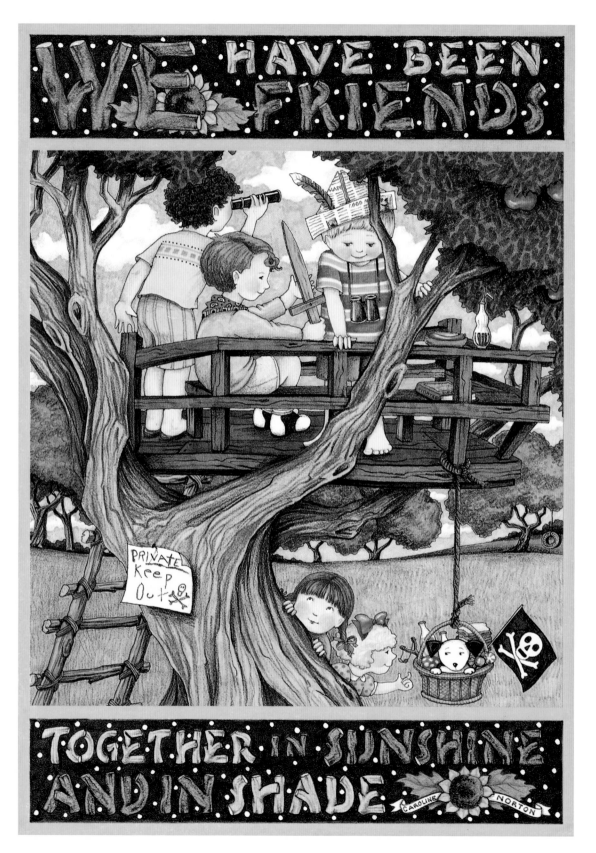

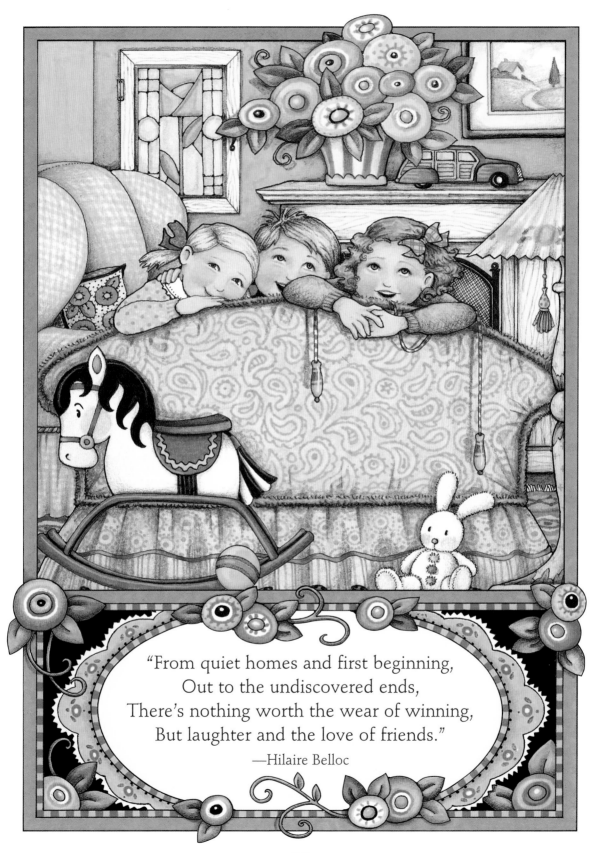

"From quiet homes and first beginning,
Out to the undiscovered ends,
There's nothing worth the wear of winning,
But laughter and the love of friends."
—Hilaire Belloc

Oh, the comfort,
the inexpressible comfort of feeling safe with a person,
having neither to weigh thoughts, nor measure words,
but pouring them out, just as they are, chaff and grain together,
certain that a faithful hand will take and sift them,
keep what is worth keeping,
and with a breath of kindness blow the rest away.

—George Eliot

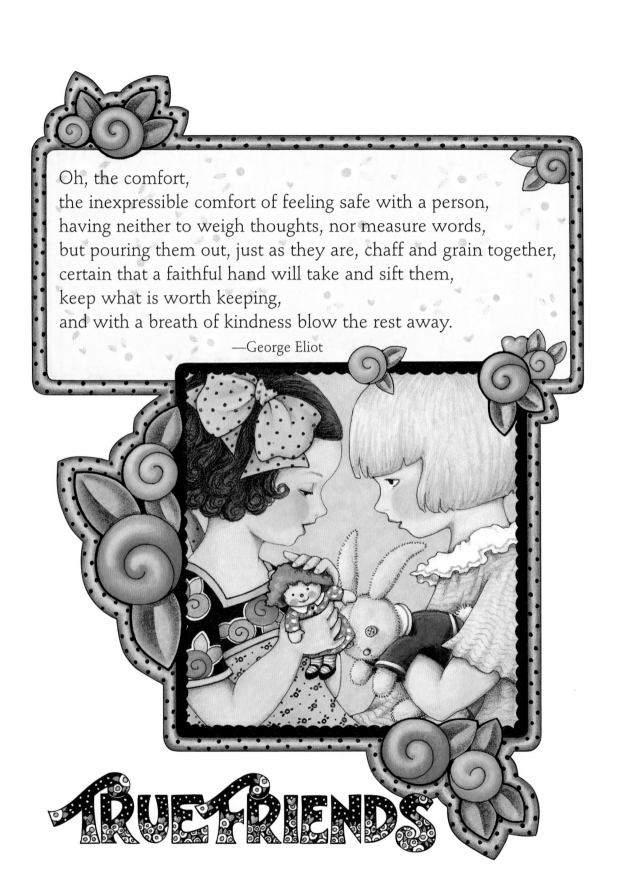

TRUE FRIENDS

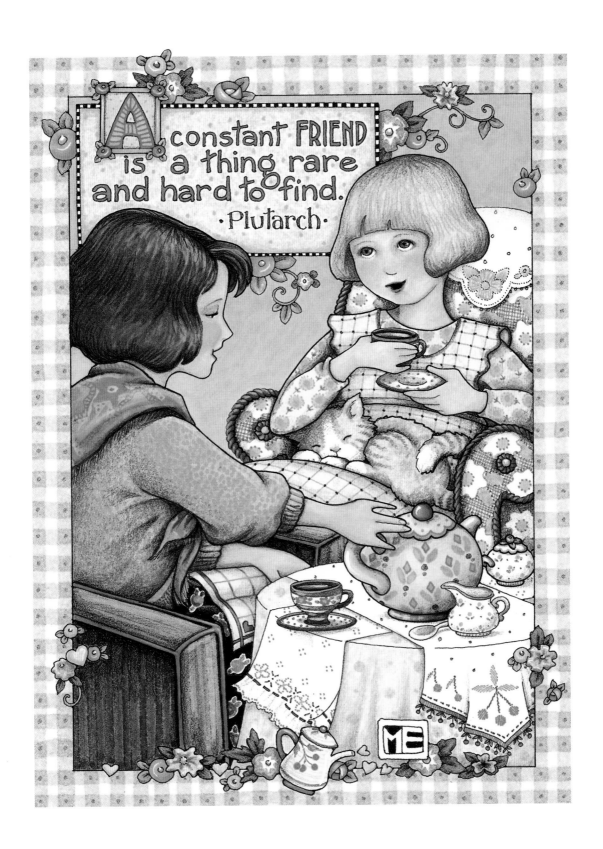

A constant FRIEND is a thing rare and hard to find.
· Plutarch ·

ircle of Friends

Maeve Binchy

They practiced hard at being reliable. If either said she would be home at six o'clock then five minutes before the hour struck and the Angelus rang she would be back in place. As Eve had anticipated, it did win them much more freedom. They were thought to be a good influence on each other. They didn't allow their hysterical laughing fits to be seen in public.

They pressed their noses against the window of Healy's Hotel. They didn't like Mrs. Healy. She was very superior. She walked as if she were a queen. She always seemed to look down on children.

Benny heard from Patsy that the Healys had been up to Dublin to look for a child to adopt but they hadn't got one because Mr. Healy had a weak chest.

"Just as well," Eve had said unsympathetically. "They'd be terrible for anyone as a mother and father." She spoke in innocence of the fact that Knockglen had once thought that she herself might be the ideal child for them.

Mr. Healy was much older than his wife. It was whispered, Patsy said, that he couldn't cut the mustard. Eve and Benny spent long hours trying to work out what this could mean. Mustard came in a small tin and you mixed it with water. How did you cut it? Why should you cut it?

Mrs. Healy looked a hundred but apparently she was twenty-seven. She had married at seventeen and was busy throwing all her efforts into the hotel since there were no children.

Together they explored places where they had never gone alone. To Flood's, the butchers, hoping they might see the animals being killed.

"We don't really want to see them being killed do we?" Benny asked fearfully.

"No, but we'd like to be there at the beginning so that we could if we want to, then run away," Eve explained. Mr. Flood wouldn't let them near his yard so the matter didn't arise.

They stood and watched the Italian from Italy come and start up his fish-and-chip shop.

"Weel you leetle girls come here every day and buy my feesh?" he said hopefully to the two earnest children, one big, one small, who stood watching his every move.

"No, I don't think we'll be allowed," Eve said sadly.

"Why is that?"

"It would be called throwing away good money," Benny said.

"And talking to foreign men," Eve explained to clinch matters.

"My seester is married to a Dublin man," Mario explained.

"We'll let people know," Eve said solemnly.

Sometimes they went to the harness maker. A very handsome man on a horse came one day to inquire about a bridle that should have been ready, but wasn't.

Dekko Moore was a cousin of Paccy Moore's in the shoe shop. He was very apologetic, and looked as if he might be taken away and hanged for the delay.

The man turned his horse swiftly. "All right. Will you bring it up to the house tomorrow, instead," he shouted.

"Indeed I will sir, thank you sir. I'm very sorry sir. Indeed sir." Dekko Moore sounded like a villain who had been unmasked in a pantomime.

"Lord, who was that I wonder?" Benny was amazed. Dekko was almost dead with relief at how lightly he had escaped.

"That was Mr. Simon Westward," Dekko said, mopping his brow.

"I thought it must be," Eve said grimly.

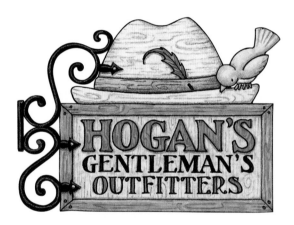

Sometimes they went into Hogan's Gentleman's Outfitters. Father always made a huge fuss of them. So did old Mike, and anyone else who happened to be in the shop.

"Will you work here when you're old?" Eve had whispered.

"I don't think so. It'll have to be a boy, won't it?"

"I don't see why," Eve had said.

"Well, measuring men, putting tape measures round their waists, and all."

They giggled.

"But you're the boss's daughter, you wouldn't be doing that. You'd just be coming in shouting at people, like Mrs. Healy does over in the hotel."

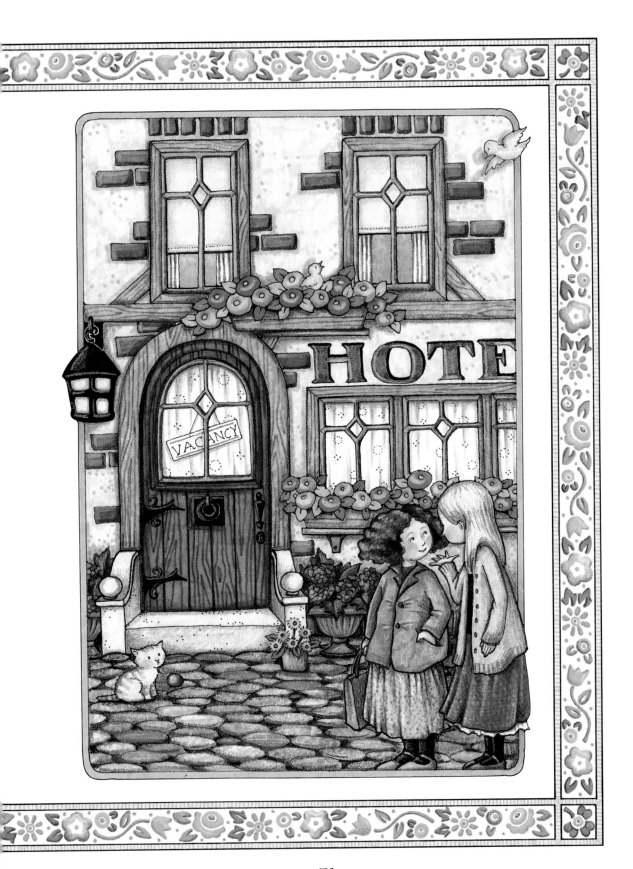

"Um." Benny was doubtful. "Wouldn't I need to know what to shout about?"

"You could learn. Otherwise Droopy Drawers will take over."

That's what they called Sean Walsh who seemed to have become paler, thinner and harder of the eye since his arrival.

"No, he won't, surely?"

"You could marry him."

"Ugh. Ugh. Ugh."

"And have lots of children by putting your belly button beside his."

"Oh, Eve, I'd hate that. I think I'll be a nun."

"I think I will too. It would be much easier. You can go any day you like, lucky old thing. I have to wait until I'm twenty-one." Eve was disconsolate.

"Maybe she'd let you enter with me, if she knew it was a true vocation." Benny was hopeful.

Her father had run out of the shop and now he was back with two lollipops. He handed them one each proudly.

"We're honored to have you ladies in our humble premises," he said, so that everyone could hear him.

Soon everyone in Knockglen thought of them as a pair. The big stocky figure of Benny Hogan in her strong shoes and tightly buttoned sensible coat, the waiflike Eve in the clothes that were always too long and streetish on her. Together they watched the setting up of the town's first fish-and-chip shop, they saw the decline of Mr. Healy in the hotel and stood side by side on the day that he was taken to the sanatorium. Together they were unconquerable. There was never an ill-considered remark made about either of them.

When Birdie Mac in the sweetshop was unwise enough to say to Benny that those slabs of toffee were doing her no good at all, Eve's small face flashed in a fury.

"If you worry so much about things, Miss Mac, then why do you sell them at all?" she asked in tones that knew there could be no answer.

When Maire Carroll's mother said thoughtfully to Eve, "Do you know I always ask myself why a sensible woman like Mother Francis would let you out on the street looking like Little Orphan Annie," Benny's brow darkened.

"I'll tell Mother Francis you wanted to know," Benny had said quickly. "Mother Francis says we should have inquiring minds, that everyone should ask."

Before Mrs. Carroll could stop her Benny had galloped out of the shop and up the road toward the convent.

"Oh, Mam, you've done it now," Maire Carroll moaned. "Mother Francis will be down on us like a ton of bricks."

And she was. The full fiery rage of the nun was something that Mrs. Carroll had not expected and never wanted to know again.

None of these things upset either Eve or Benny in the slightest. It was easy to cope with Knockglen when you had a friend.

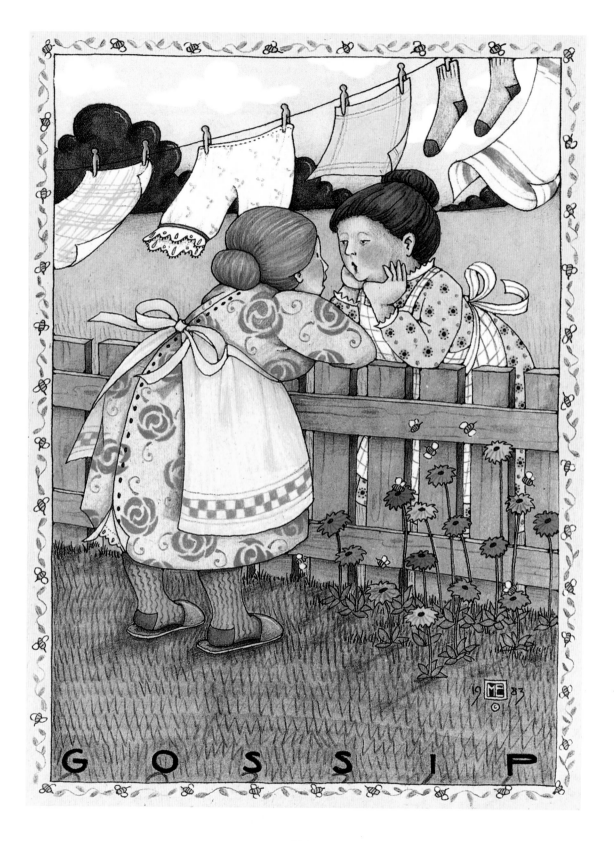

GOSSIP

The Friendly Neighbor

Betty G. Ahearn

My next door neighbor is a friend
On whom I know I can depend,
Because when I feel shut inside,
I know her door is open wide.

You know the kind . . . they always do
So many loving deeds for you.
And little things with you they share
To show you that they really care.

If you should find your pantry store
Is low, how nice to run next door,
And borrow maybe some rare spice
Or something as humdrum as plain rice.

And on occasions when you go
On trips, it's comforting to know
When you return her window light
Will brighten up the darkest night.

I'm thankful for this neighborly tie
That binds me to the house nearby,
And may I never fail to be
The kind of friend she is to me.

Companioned

Lee Avery

People I love are with me all the while,
Wherever I may walk, they go with me.
A dancing thought of one persuades a smile,
Another's interest shares the things I see.
Companioned ever, even in the night
When sleep evades, I have a wealth of reels
Projected on the screen of mind's delight;
I share a thought that someone distant feels.
People I love, an ever-growing band!
All warm and cherished, close within my heart,
Forever bound by things we understand,
And, by these bonds, not ever quite apart.
So rich am I, in love and goodness known,
My steps are buoyant…I am not alone.

IMAGINE

PEACE

HARMONY

HOPE

LOVE

TOLERANCE

RESPECT

In the end,
we will remember not
the words of our enemies,
but the silence of our friends.

~Martin Luther King, Jr.

I'D LIKE TO BE THE SORT of FRIEND THAT YOU HAVE BEEN TO ME
I'D LIKE TO BE THE HELP THAT YOU'VE BEEN ALWAYS GLAD TO BE;
I'D LIKE TO MEAN AS MUCH TO YOU EACH MINUTE OF THE DAY
AS YOU HAVE MEANT, OLD FRIEND of MINE, TO ME ALONG THE WAY

· EDGAR A. GUEST ·

An American Childhood
Annie Dillard

Even my friends began to seem to me marvelous: Judy Schoyer laughing shyly, her round eyes closed, and quick Ellin Hahn, black-haired and ruddy, who bestrode the social world like a Colossus, saying always just the right and funny thing. Where had these diverse people come from, really? I watched little Molly turn from a baby into a child and become not changed so much as ever more herself, kind-hearted, nervous, both witty and humorous: was this true only in retrospect? People's being themselves, year after year, so powerfully and so obliviously—what was it? Why was it so appealing? Personality, like beauty, was a mystery; like beauty, it was useless. These useless things were not, however, flourishes and embellishments to our life here, but that life's center; they were its truest note, the heart of its form, which drew back our thoughts repeatedly.

True happiness is of a retired nature,
and an enemy to pomp and noise;
it arises, in the first place,
from the enjoyment of one's self;
and, in the next,
from the friendship and conversation
of a few select companions.
—Joseph Addison

It is a sweet thing, friendship, a dear balm,
A happy and auspicious bird of calm...
—Percy Bysshe Shelley

MUCH AS WORTHY FRIENDS ADD TO THE HAPPINESS & VALUE OF LIFE, WE MUST IN THE MAIN DEPEND UPON OURSELVES, AND EVERY ONE IS HIS OWN BEST FRIEND OR WORST ENEMY.

LORD EVEBURY

2 Cute
+ 2 Be
4 Gotten

LYLAS
(Love you like a sister)
-Natalie ♡

◼══════MY AUTOGRAPH ALBUM══

Ottis Shirk

R.M.A.
Remember me
always!
-Wende

This autograph album I had when a child
As I turn through its pages with care,
Bring back the memories of days long ago,
As I read the dim lines written there.
Once it was spotless, each page white as snow,
And now they have yellowed with age,
But there neatly written by the hand of some friend
Is a line or a verse on each page.

This autograph album was a gift from a friend,
A memento of thoughtful affection,
Her life an example of the lessons she taught,
I admire in fond recollection.
On the first page she wrote a short Scripture text
And above her own name she has written these words:
"A gift from your Sunday School Teacher."

Remember me now;
remember me forever,
remember the fun
we had together.
always, Lynn ♡

BFF!
(Best Friends
Forever)
♡ - Jennifer

2 Gether
4 Ever!

Stay as sweet as you are!
love, Ann

Roses are red,
Violets are blue,
my life is blessed
with friends like you.

Forget me not, remember me always.
- Rae

Lines such as these, and others I find
Autographed on each faded page,
"May friendship and truth be with you in youth,
and happiness bless your old age."
"Here's from a friend who is far away,
But of you this friend often thinks,
And in the golden chain of your friendship
Please regard me as one of the links."

2 Young.
2 Fall.
4 Boys.

Just a faded old book, but ah, what a guide,
What a help to retrace memory's lane,
What fond recollections it brings back to mind
Of memories I'm glad to reclaim.
The jewels of friendship between the covers
Still have a sparkle and shine,
And I find it a joy and pleasure to read
That autograph album of mine.

Don't ever change!
-Katey

I like you early.
I like you late.
I like you best
as my classmate.
love ya, Jan

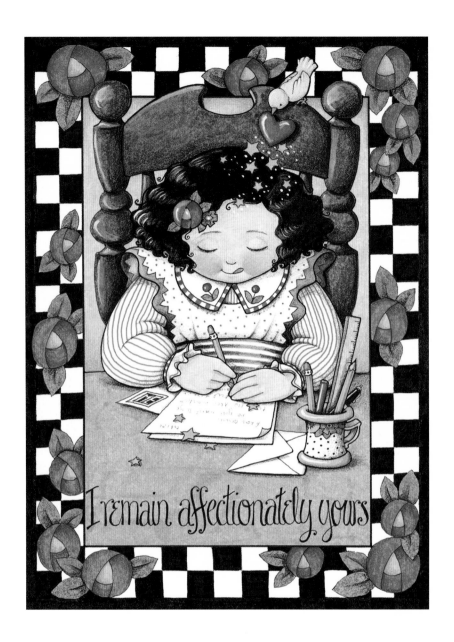

I remain affectionately yours

Everybody allows that the talent
of writing agreeable letters is peculiarly female.
—Jane Austen

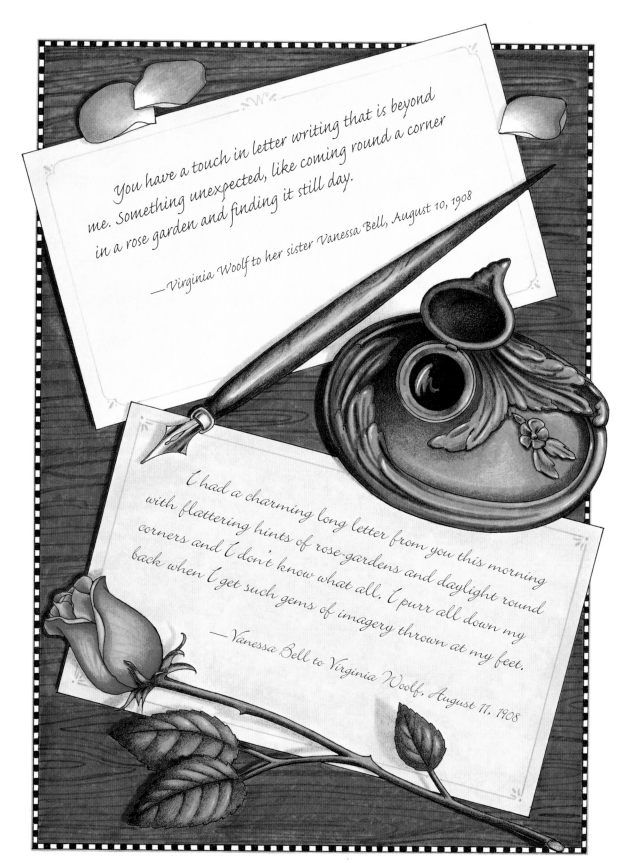

You have a touch in letter writing that is beyond me. Something unexpected, like coming round a corner in a rose garden and finding it still day.

—Virginia Woolf to her sister Vanessa Bell, August 10, 1908

I had a charming long letter from you this morning with flattering hints of rose-gardens and daylight round corners and I don't know what all. I purr all down my back when I get such gems of imagery thrown at my feet.

—Vanessa Bell to Virginia Woolf, August 11, 1908

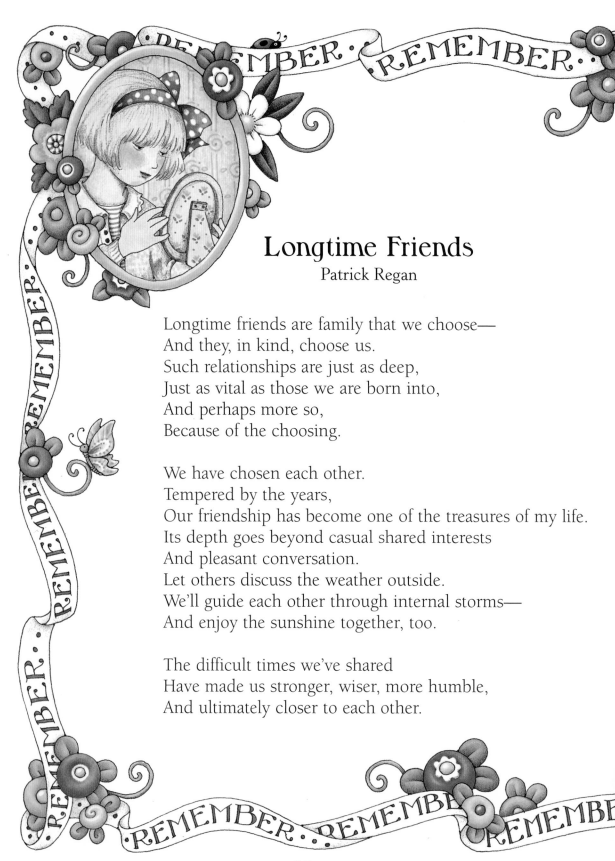

Longtime Friends

Patrick Regan

Longtime friends are family that we choose—
And they, in kind, choose us.
Such relationships are just as deep,
Just as vital as those we are born into,
And perhaps more so,
Because of the choosing.

We have chosen each other.
Tempered by the years,
Our friendship has become one of the treasures of my life.
Its depth goes beyond casual shared interests
And pleasant conversation.
Let others discuss the weather outside.
We'll guide each other through internal storms—
And enjoy the sunshine together, too.

The difficult times we've shared
Have made us stronger, wiser, more humble,
And ultimately closer to each other.

Our friendship is not practiced, but intuitive.
We know when the other needs attention,
reassurance, empathy, solitude,
Or a gentle push in the right direction.

Within a well-worn friendship like ours,
Permission isn't always asked, nor is it required.
And the grand gestures of etiquette are often forgone.
But as the years continue to pass,
I know we'll never take it for granted
Or let it suffer from neglect.

As we grow older and our lives grow more complex,
It seems that we have less time for each other—
and the time we do have always leaves me wanting more.
But even during those periods when we're pulled in different directions,
Our friendship is just as alive, just as resonant to me
As when we are enjoying each other's company.

We've taught each other
That when friendship is true,
A hand can be held from miles away.

Our friendship will always last
Because it continues to grow,
And because, through the years,
We continue to choose each other.

Perhaps the most delightful friendships
are those in which there is much agreement,
much disputation, and yet more personal liking.
—George Eliot

A friend is a person with whom I may be sincere.
Before him, I may think aloud.
—Ralph Waldo Emerson

None is so perfect that he may not
at times lend an ear to friendly advice.
—Baltasar Gracián

I've discovered a way to stay friends forever—
there's really nothing to it.
I simply tell you what to do and you do it!
—Shel Silverstein

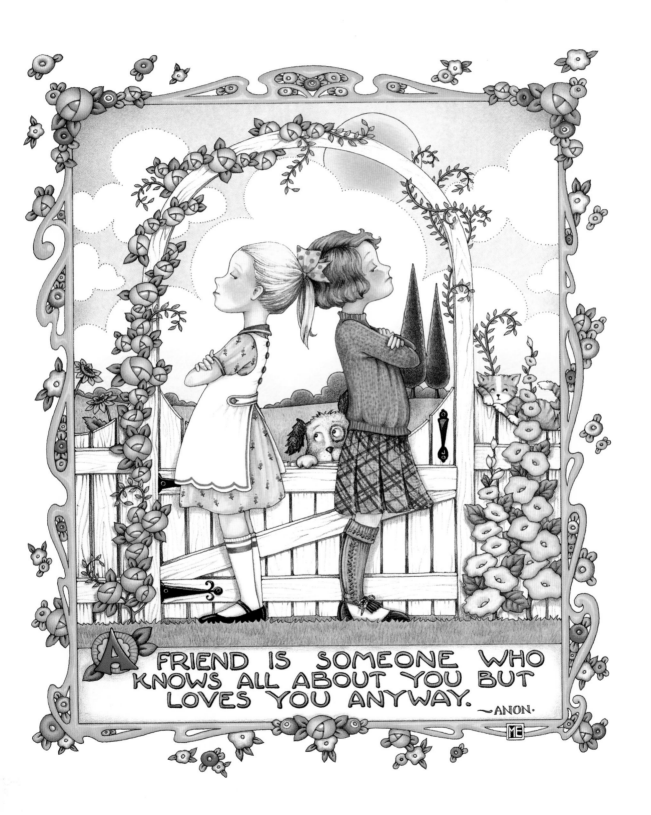

A FRIEND IS SOMEONE WHO KNOWS ALL ABOUT YOU BUT LOVES YOU ANYWAY. ~ANON.

Toasts to Friendship

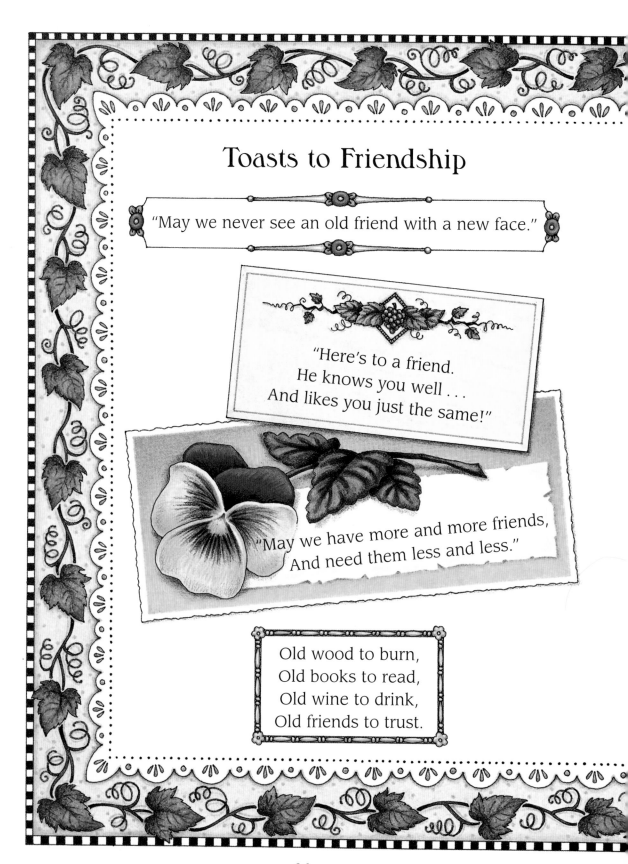

"May we never see an old friend with a new face."

"Here's to a friend.
He knows you well . . .
And likes you just the same!"

"May we have more and more friends,
And need them less and less."

Old wood to burn,
Old books to read,
Old wine to drink,
Old friends to trust.

May your home always be
too small to hold all your friends.

I wish you health, I wish you well, and happiness galore.
I wish you luck for you and friends;
what could I wish you more?
May your joys be as deep as the oceans,
your troubles as light as its foam.
And may you find, sweet peace of mind,
wherever you may roam.

May your right hand always
Be stretched out in friendship
And never in want.

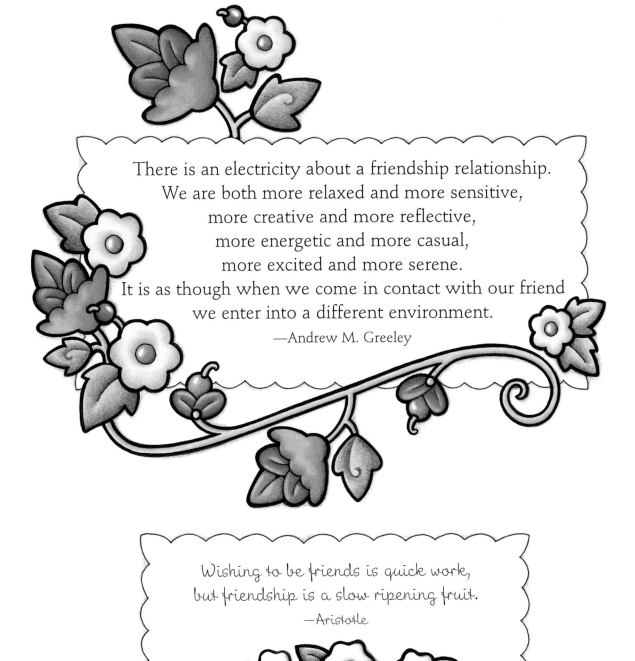

There is an electricity about a friendship relationship.
We are both more relaxed and more sensitive,
more creative and more reflective,
more energetic and more casual,
more excited and more serene.
It is as though when we come in contact with our friend
we enter into a different environment.
—Andrew M. Greeley

Wishing to be friends is quick work,
but friendship is a slow ripening fruit.
—Aristotle

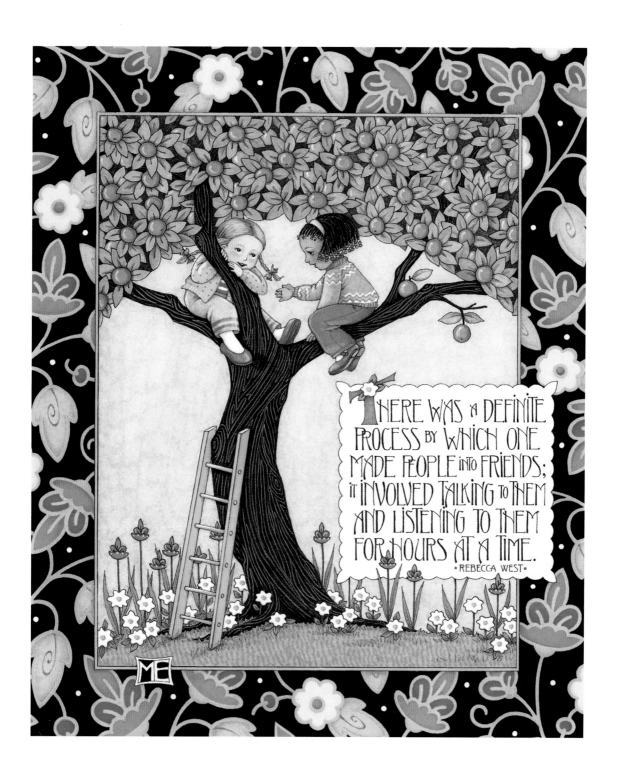

THERE WAS A DEFINITE PROCESS BY WHICH ONE MADE PEOPLE INTO FRIENDS; IT INVOLVED TALKING TO THEM AND LISTENING TO THEM FOR HOURS AT A TIME.
• REBECCA WEST •

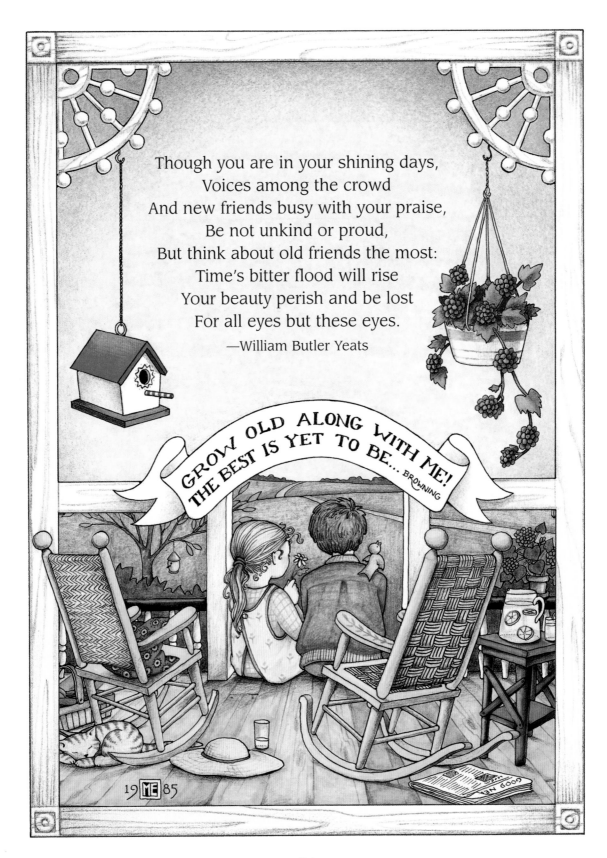

Though you are in your shining days,
Voices among the crowd
And new friends busy with your praise,
Be not unkind or proud,
But think about old friends the most:
Time's bitter flood will rise
Your beauty perish and be lost
For all eyes but these eyes.
—William Butler Yeats

GROW OLD ALONG WITH ME!
THE BEST IS YET TO BE... BROWNING

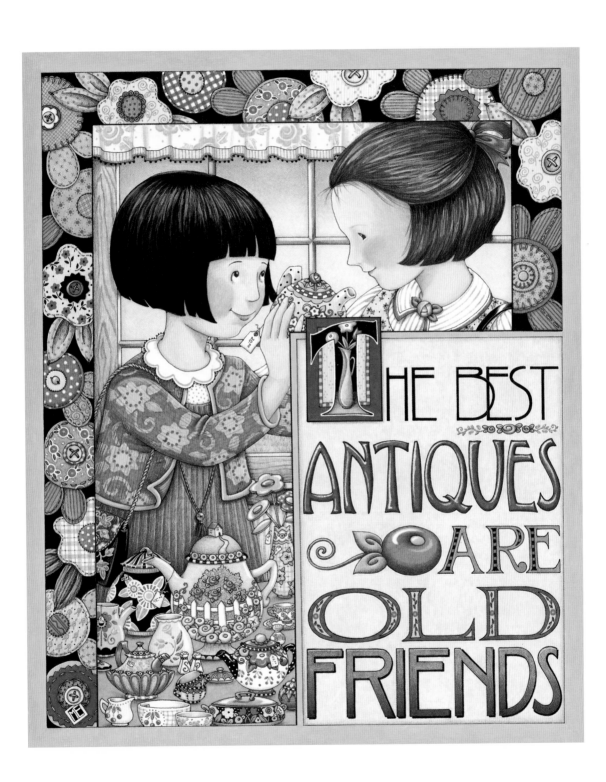

THE BEST ANTIQUES ARE OLD FRIENDS

Old Friends

Mary McCaslin

Saw an old friend the other day,
In San Francisco, by the bay;
It took me back to only yesterday,
the years somehow, that slip away.

We laughed and talked about the days gone by,
And brushed a tear away, with a sigh;
We promised not to let it be this long,
Like the old refrain from an old, old song.

Remember old friends we've made along the way.
The gifts they've given stay with us everyday.

Lookin' back it makes me wonder,
Where we're going, how long we'll stay;
I know the road brings rain and thunder,
But for the journey, what will we pay?

I often think the times get crazier
As this old world goes round and round;
But just the memory makes it easier
As the highway goes up and down.

Remember old friends we've made along the way.
The gifts they've given stay with us everyday.

Lately word's been coming back to me
There's a few I will no longer see
Their faces will be seen no more along the road,
There'll be a few less hands to hold.

But for the one's whose journey's ended,
Though they started so much the same,
In the hearts of those befriended
Burns a candle with a silver flame.

Remember old friends we've made along the way.
The gifts they've given stay with us everyday.

A Few Shells

Anne Morrow Lindbergh

I am packing to leave my island. What have I for my efforts, for my ruminations on the beach? What answers or solutions have I found for my life? I have a few shells in my pocket, a few clues, only a few.

When I think back to my first day here, I realize how greedily I collected. My pockets bulged with wet shells, the damp sand clinging to their crevices. The beach was covered with beautiful shells and I could not let one go by unnoticed. I couldn't even walk head up looking out to sea, for fear of missing something precious at my feet. The collector walks with blinders on; he sees nothing but the prize. In fact, the acquisitive instinct is incompatible with true appreciation of beauty. But after all the pockets were stretched and damp, and the bookcase shelves filled and the window ledges covered, I began to drop my acquisitiveness. I began to discard from my possessions, to select.

One cannot collect all the beautiful shells on the beach. One can collect only a few, and they are more beautiful if they are few. One moon shell is more impressive than three. There is only one moon in the sky. One double-sunrise is an event; six are a succession, like a week of schooldays. Gradually one discards and keeps just the perfect specimen; not necessarily a rare shell, but a perfect one of its kinds. One sets it apart by itself, ringed around by space—like the island.

For it is only framed in space that beauty blooms. Only in space are events and objects and people unique and significant—and therefore beautiful. A tree has significance if one sees it against the empty face of sky.

A note in music gains significance from the silences on either side. A candle flowers in the space of night. Even small and casual things take on significance if they are washed in space, like a few autumn grasses in one corner of an Oriental painting, the rest of the page bare.

Here on this island I have had space. Paradoxically, in this limited area, space has been forced upon me. The geographical boundaries, the physical limitations, the restrictions on communication, have enforced a natural selectivity. There are not too many activities or things or people, and each one, I find, is significant, set apart in the frame of sufficient time and space. Here there is time; time to be quiet; time to work without pressure; time to think; time to watch the heron, watching with frozen patience for his prey. Time to look at the stars or to study a shell; time to see friends, to gossip, to laugh, to talk. Time, even *not* to talk. At home, when I meet my friends in those cubby-holed hours, time is so precious we feel we must cram every available instant with conversation. We cannot afford the luxury of silence. Here on the island I find I can sit with a friend without talking, sharing the day's last sliver of pale green light on the horizon, or the whorls in a small white shell, or the dark scar left in a dazzling night sky by a shooting star. Then communication becomes communion and one is nourished as one never is by words.

My island selects for me socially too. Its small circumference cannot hold too many people. I see people here that I would not see at home, people who are removed from me by age or occupation. In the suburbs of a large city we tend to see people of the same general age and interests. That is why we chose the suburbs, because we have similar needs and pursuits. My island selects for me people who are very different from me—the stranger who turns out to be, in the frame of sufficient time and space, invariably interesting and enriching. I discover here what everyone has experienced on an ocean voyage or a long train ride or a temporary seclusion in a small village.

Out of the welter of life, a few people are selected for us by the accident of temporary confinement in the same circle. We never would have chosen these neighbors; life chose them for us. But thrown together on this island of living, we stretch to understand each other and are invigorated by the stretching. The difficulty with big city environment is that we select—and we must in order to live and breathe and work in such crowded conditions— we tend to select people like ourselves, a very monotonous diet. All hors d'oeuvres and no meat; or all sweets and no vegetables, depending on the kind of people we are. But however much the diet may differ between us, one thing is fairly certain: we usually select the known, seldom the strange. We tend not to choose the unknown which might be a shock or a disappointment or simply a little difficult to cope with. And yet it is the unknown with all its disappointments and surprises that is the most enriching.

In so many ways this island selects for me better than I do myself at home. When I go back will I be submerged again, not only be centrifugal activities, but by too many centripetal ones? Not only by distractions but by too many opportunities? Not only by dull people but by too many interesting ones? The multiplicity of the world will crowd in on me again with its false sense of values. Values weighed in quantity, not quality; in speed, not stillness; in noise, not silence; in words, not in thoughts; in acquisitiveness, not beauty.

For the natural selectivity of the island I will have to substitute a conscious selectivity based on another sense of values—a sense of values I have become more aware of here. Island-precepts, I might call them if I could define them, signposts toward another way of living. Simplicity of living, as much as possible, to retain a true awareness of life. Balance of physical, intellectual, and spiritual life. Work without pressure. Space for significance and beauty. Time for solitude and sharing. Closeness to nature to strengthen understanding and faith in the intermittency of life: life of the spirit, creative life, and the life of human relationships. A few shells.

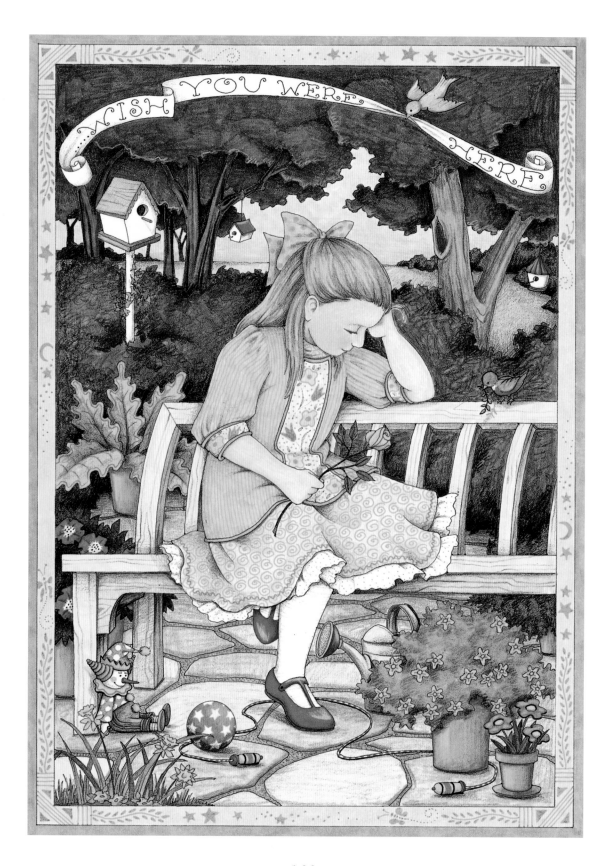

One can afford to lose a great deal on this earth
when the sun shines on it, & not feel any the worse
for the loss: but a single shred of human affection,
one can't afford to lose, —tho' the sun & moon
& stars shone all at once!
—Elizabeth Barrett

We are, each of us angels with only one wing;
and we can only fly by embracing one another.
—Luciano de Crescenzo

THERE'S SO MUCH GOOD IN THE WORST OF US
AND SO MUCH BAD IN THE BEST OF US
THAT IT ILL BEHOVES ANY OF US
TO TALK ABOUT THE REST OF US.

—JULIE'S GRANDMA

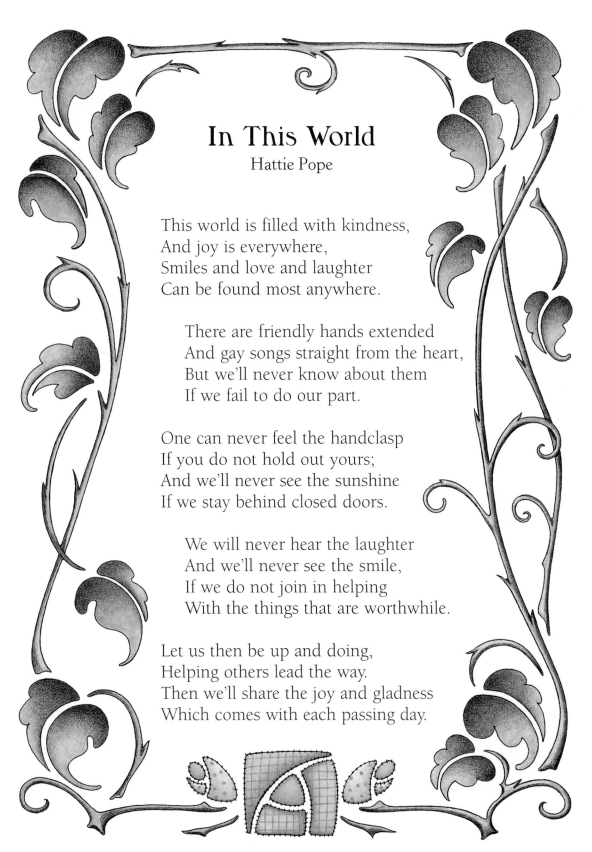

In This World

Hattie Pope

This world is filled with kindness,
And joy is everywhere,
Smiles and love and laughter
Can be found most anywhere.

There are friendly hands extended
And gay songs straight from the heart,
But we'll never know about them
If we fail to do our part.

One can never feel the handclasp
If you do not hold out yours;
And we'll never see the sunshine
If we stay behind closed doors.

We will never hear the laughter
And we'll never see the smile,
If we do not join in helping
With the things that are worthwhile.

Let us then be up and doing,
Helping others lead the way.
Then we'll share the joy and gladness
Which comes with each passing day.

The Prophet
Kahlil Gibran

And a youth said, "Speak to us of Friendship."

Your friend is your needs answered.

He is your field which you sow with love and reap with thanksgiving.

And he is your board and your fireside.

For you come to him with your hunger, and you seek him for peace.

When your friend speaks his mind you fear not the "nay" in your own mind, nor do you withhold the "ay."

And when he is silent your heart ceases not to listen to his heart;

For without words, in friendship, all thoughts, all desires, all expectations are born and shared, with joy that is unacclaimed.

When you part from your friend, you grieve not;

For that which you love most in him may be clearer in his absence, as the mountain to the climber is clearer from the plain.

And let there be no purpose in friendship save the deepening
 of the spirit.
For love that seeks aught but the disclosure of its own mystery is not
 love but a net cast forth: and only the unprofitable is caught.
And let your best be for your friend.
If he must know the ebb of your tide, let him know its flood also.
For what is your friend that you should seek him with hours to kill?
Seek him always with hours to live.
For it is his to fill your need, but not your emptiness.
And in the sweetness of friendship let there be laughter,
 and sharing of pleasures.
For in the dew of little things the heart finds its morning
 and is refreshed.

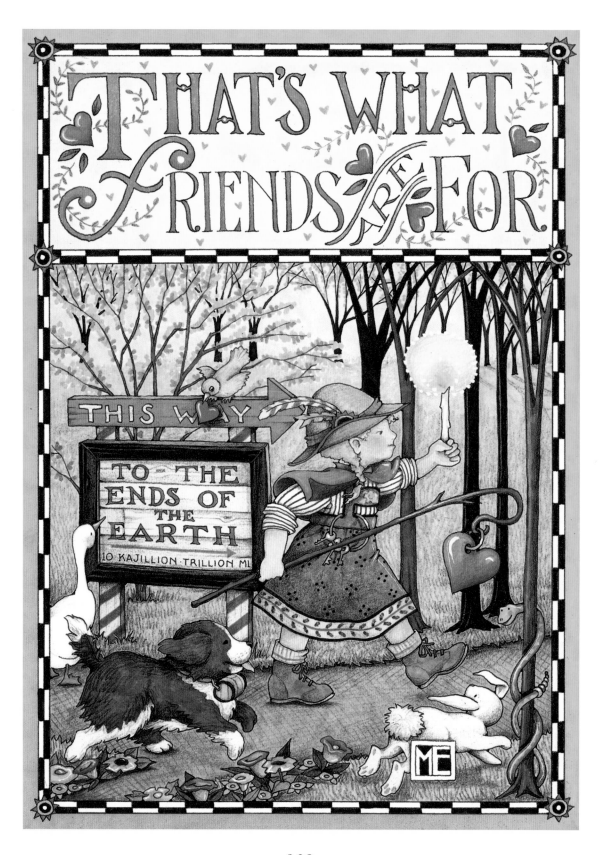

THAT'S WHAT FRIENDS ARE FOR.

THIS WAY

TO · THE
ENDS OF
THE
EARTH
10 KAJILLION · TRILLION · MI

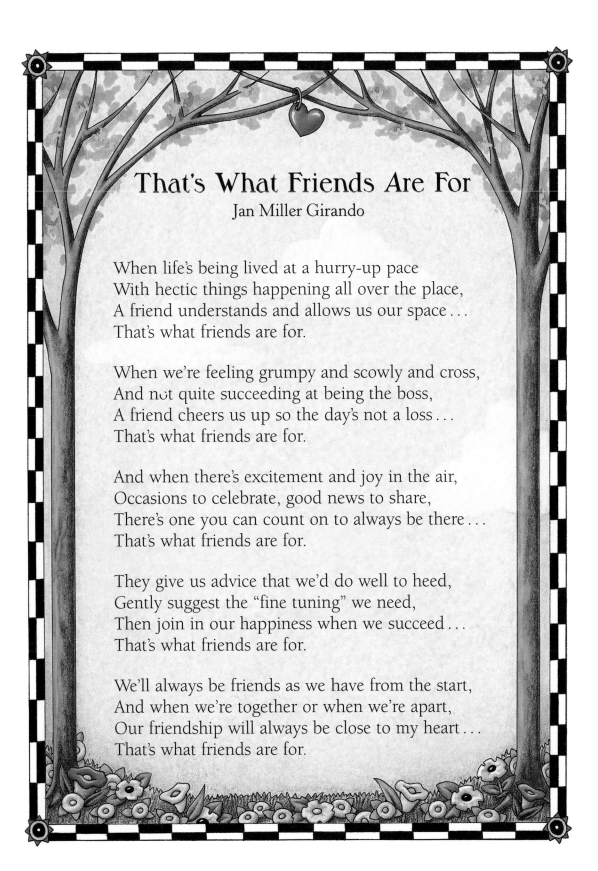

That's What Friends Are For
Jan Miller Girando

When life's being lived at a hurry-up pace
With hectic things happening all over the place,
A friend understands and allows us our space...
That's what friends are for.

When we're feeling grumpy and scowly and cross,
And not quite succeeding at being the boss,
A friend cheers us up so the day's not a loss...
That's what friends are for.

And when there's excitement and joy in the air,
Occasions to celebrate, good news to share,
There's one you can count on to always be there...
That's what friends are for.

They give us advice that we'd do well to heed,
Gently suggest the "fine tuning" we need,
Then join in our happiness when we succeed...
That's what friends are for.

We'll always be friends as we have from the start,
And when we're together or when we're apart,
Our friendship will always be close to my heart...
That's what friends are for.

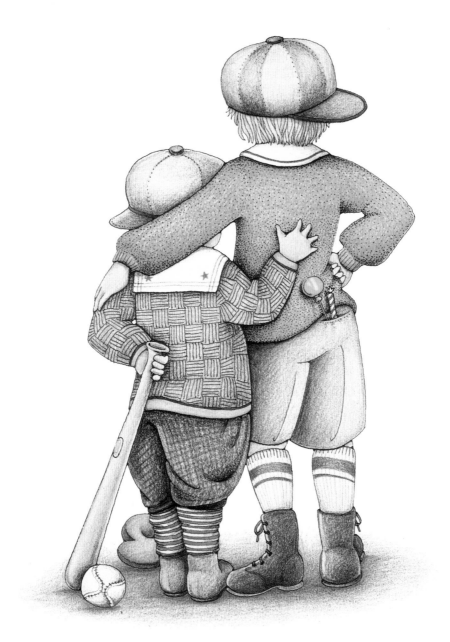

A brother is a friend provided by nature.
—Legouve Pere

The Friend Who Just Stands By
Author Unknown

When trouble comes your soul to try
You love the friend who just stands by.
Perhaps there's nothing he can do;
The thing is strictly up to you,
For there are troubles all your own,
And paths the soul must tread alone;
Times when love can't smooth the road,
Nor friendship lift the heavy load.

But just to feel you have a friend,
Who will stand by until the end;
Whose sympathy through all endures,
Whose warm handclasp is always yours,
It helps somehow to pull you through
Although there's nothing he can do;
And so with fervent heart we cry,
"God bless the friend who just stands by."

The glory of friendship is not the outstretched hand,
nor the kindly smile nor the joy of companionship;
it is the spiritual inspiration
that comes to one when he discovers
that someone else believes in him
and is willing to trust him.
—Ralph Waldo Emerson

I do then with my friends as I do with my books.
I would have them where I can find them,
but I seldom use them.
—Ralph Waldo Emerson

Happy is the house that shelters a friend.
—Ralph Waldo Emerson

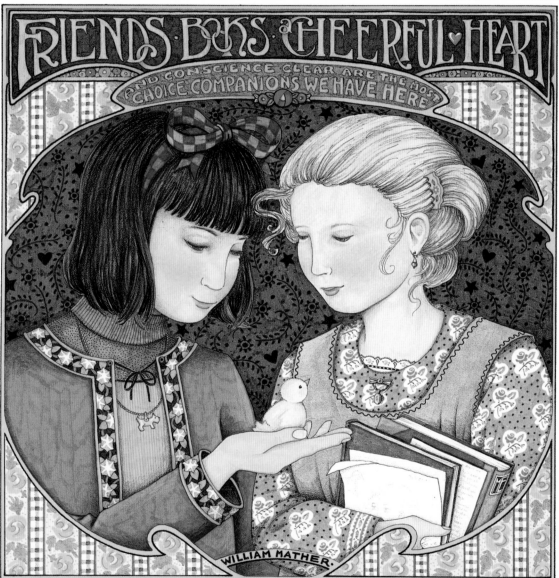

FRIENDS·BRING·A·CHEERFUL·HEART

AND CONSCIENCE CLEAR ARE THE MOST CHOICE COMPANIONS WE HAVE HERE

WILLIAM MATHER.

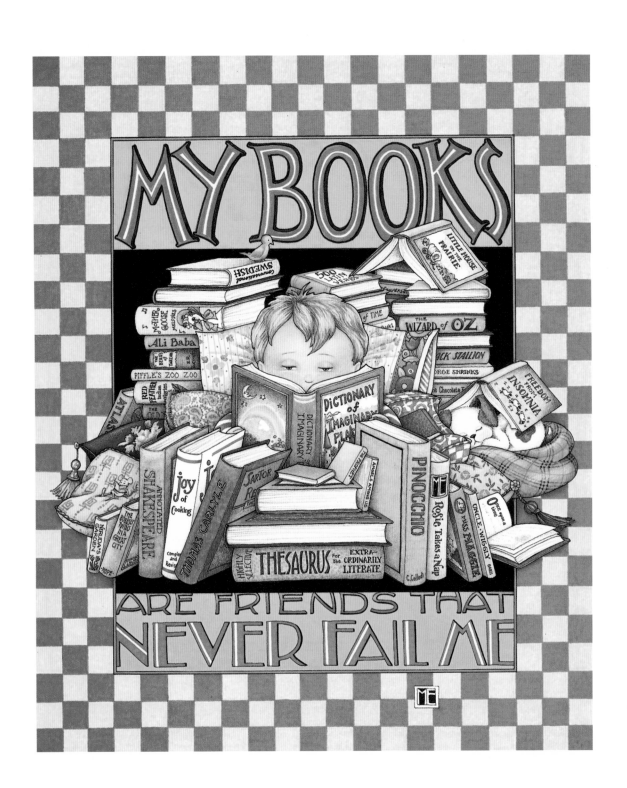

Candide

Richard Wilbur

Life is happiness indeed
Mares to ride and books to read
Though of noble birth I'm not
I'm delighted with my lot
Though I've no distinctive features
And I've no official mother
I love all my fellow creatures
And the creatures love each other

Friends Are Like the Sun

Mary Korzan

I watched the sun nestle down in the clouds
camouflaging them in colors
of red and pink and distant blues.
I watched as it touched and changed shadows
and water and me
inside out.
I am absolutely sure
that friends are like the sun.
The joy is the same in their coming
as is the sadness
at their parting
and sometimes
you might not see them
for a whole hour
or night
or more…
But you know that they will come back
like the sun
because there is promise
in the stars.

If I Could Catch a Rainbow

Author Unknown

If I could catch a rainbow
I would do it
Just for you
And share with you
It's beauty
On the days you're feeling blue
If I could build a mountain
You could call
Your very own
A place to find serenity
A place to be alone

If I could
Take your troubles
I would toss them
In the sea
But all these things
I'm finding
Are impossible for me
I cannot build a mountain
Or catch a rainbow fair
But let me be
What I know best
A friend
That's always there.

O traveler, who hast wandered far
'Neath southern sun and northern star,
Say where the fairest regions are?

Friend, underneath whatever skies
Love looks in love-returning eyes,
There are the bowers of Paradise.
—Clinton Scollard

Friendship is the marriage of the soul.
—Voltaire

For the moment one says,
'I will be your friend,'
and you accept it,
it is an era quite as notable,
and as much to be accounted of,
as if it were the lover to whom one gave oneself,
body and soul, for ever!
—Geraldine Endsor Jewsbury

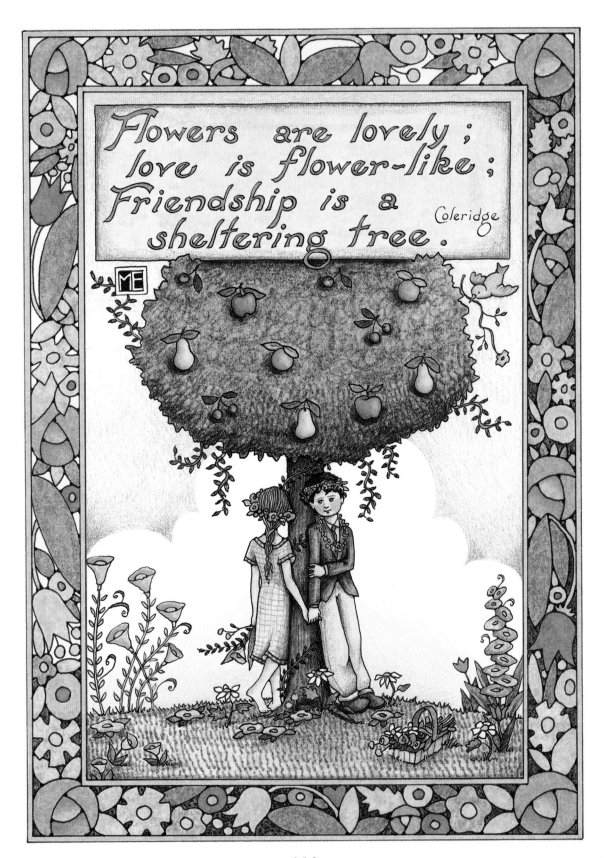

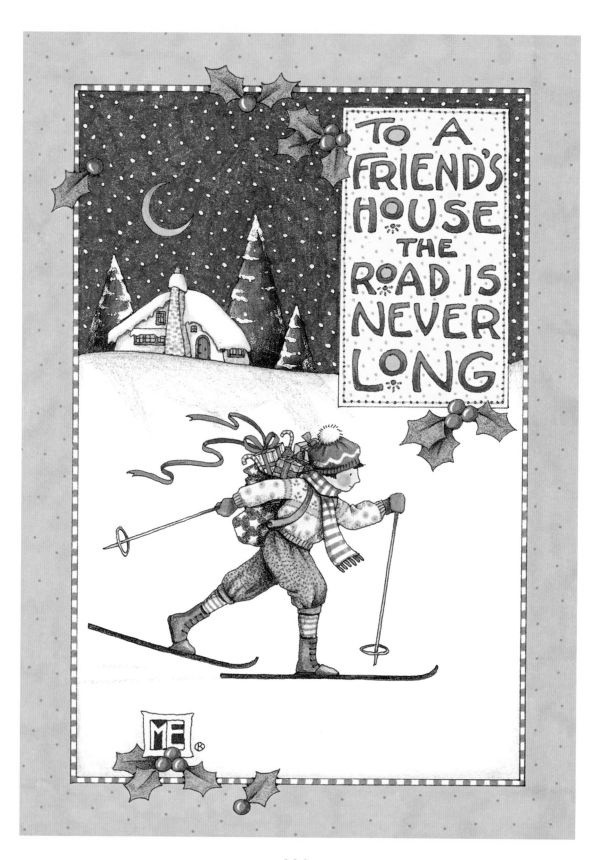

TO A FRIEND'S HOUSE THE ROAD IS NEVER LONG

A Friend

Author Unknown

I will not think that I have failed,
Or lived my life in vain,
If to my credit I shall find
One friend to be my gain,
And tho' the Road of Life is rough,
With mountains hard to climb;
I find there's joy along the way,
And the journey, it is fine.

It there's a friend beside me:
To cheer me with his song,
To smile his understanding,
When everything goes wrong;
It gives me strength and courage,
The mountains to ascend,
And I find that Life's worth living,
As long as there's a friend.

Then be not hasty when I'm gone,
To say I lived in vain
Tho' ghosts of many failures,
Like monuments remain,
But when Life's sun is sinking,
And I reach my journey's end,
Then count my earthly riches
In the number of my friends.

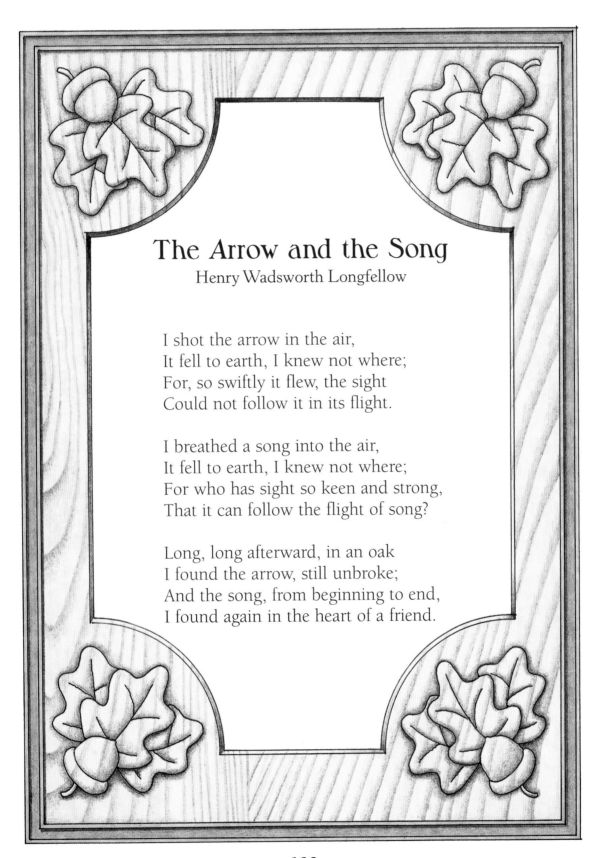

The Arrow and the Song

Henry Wadsworth Longfellow

I shot the arrow in the air,
It fell to earth, I knew not where;
For, so swiftly it flew, the sight
Could not follow it in its flight.

I breathed a song into the air,
It fell to earth, I knew not where;
For who has sight so keen and strong,
That it can follow the flight of song?

Long, long afterward, in an oak
I found the arrow, still unbroke;
And the song, from beginning to end,
I found again in the heart of a friend.

Am I Old Yet?

Leah Komaiko

Am I Old Yet? *by Leah Komaiko is the true story of an unlikely friendship between the 44-year-old children's book author and Adele, a 94-year-old blind nursing home resident whom the author agrees to "adopt" through an elder-partnering program.*

Saturday morning, when I got to the Chateau, Adele was sitting next to Mary on the sofa. They looked like two old friends who had been sitting together for hours and decided to take a little snooze. Adele opened her eyes.

"Leah?" She reached for my hand. "Did you drive your jalopy here?"

"Of course." I laughed. "Why? Did you want to go out cruising?"

"That's the ticket!" Adele quickly lifted herself from the sofa. "Let's get out of this dump!"

"Are you sure you don't want to come with us?" Adele asked Mary.

"Oh, no, honey." Mary walked us outside like she was seeing off the Titanic. "You two go ahead."

I opened the car door for Adele and helped her inside. The seatbelt alarm sounded, and Adele put her talking watch up to her ear.

"I must have set my alarm by mistake," she said. "What time is it?"

"It's eleven o'clock," I told her. "But that's not your watch. Those bells are just to remind you to put your seatbelt on. May I help you?" I asked, strapping her in. "I'm not trying to get fresh."

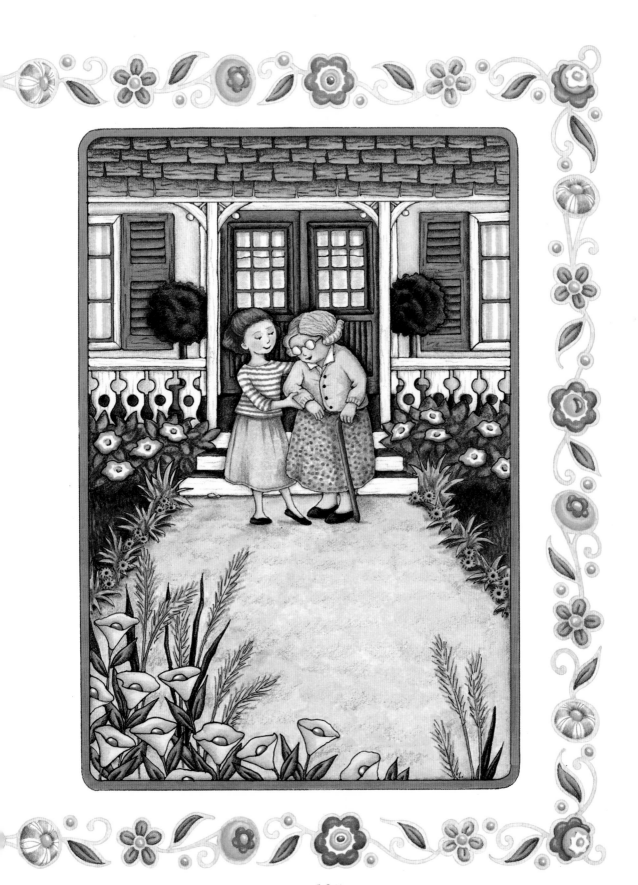

"I didn't think you were that kind of girl," Adele said. "I missed you. It's good to talk to you. Mary and I have absolutely nothing to talk about. Absolutely nothing goes on in there. I even said to Mary, 'We have nothing to talk about.'"

"What did she say?" I asked.

"Nothing!"

I suggested to Adele maybe she could start up a conversation with somebody else. "There's got to be at least one interesting person."

"There aren't many in their right mind," Adele said. "They're all in various stages of falling apart in there."

"I'm sure you're right," I said, turning onto the ramp of the San Diego Freeway. "But if it's any consolation, they're all in various stages of falling apart out here, too. The only difference is out here they have driver's licenses."

"Get out." Adele got annoyed. "I don't need bolstering."

"I know that," I said, as if I did. "And I'm not trying to bolster you." I was trying to forget the only person Adele really did have in there was me.

"Some days I wonder why I'm still alive. What purpose could God possibly still have in mind for me?" Adele asked, like I was supposed to know the answer. "What am I still doing here?"

"Well, one thing I know you're doing here for sure is changing my life," I said. "I think about you all the time. And I was thinking maybe I could write a new book."

"What's the subject matter?" Adele asked.

"I want to write about you and me and our friendship."

Adele perked up. "Get out!" she said. "You can't be serious."

"I think I may be serious."

"Oh, my God in heaven." Adele laughed with delight. "In my lifetime I never dreamed something like this would happen. Maybe I should just

start from the beginning of my life and tell you everything. Did I ever tell you about our first car? It was a Graham Page. It was one of the very good ones. I don't know what you'd call them today."

"Maybe like a luxury sedan. A Mercedes. Did you ever drive?"

"I started when the kids were very little," Adele said, like I was taking dictation. "But my eyes weren't so keen then already, and I never did get a license. My husband used to take me out for drives like this." Adele smiled. "We used to drive all the way to the cemetery where our headstones would be."

"That sounds like a pleasant destination."

"And how." Adele laughed.

"But today we're heading to the beach," I told her, like she would be thrilled at the prize I was giving her.

"Did I ever tell you we were one of the first families on our block to have a radio?" Adele asked. "It was the Atwater Kent," she said, like she was reading the name in front of her. "I remember we would put it on the table and people would open their windows to hear music coming out of the box. Sometimes we would listen to Radio Free Europe or Ma Perkins. Do you know Ma Perkins?"

"I think I've heard of her."

"These things may not all connect now," Adele said, "but later you can pull them and string them together for the book."

Then Adele turned, and I could tell she was looking at me like she suddenly realized I was crazy. "Who is going to buy a thing like this?" she said.

"Maybe no one," I assured her. "It isn't a book yet. It may never be. So far it's just an idea. I don't even know that I can write it."

"What do you mean?" Adele questioned too loudly. "Of course you can. And I think it's a great idea."

"You do?"

"Absolutely," Adele said with the fervor of a Super Bowl coach. "You can do it. You have the talent for it. You'll just do it section by section. Not that you need me to tell you how to write a book. You have my blessing. If you want, I can even help you."

I felt faintly nauseous. I didn't know how to say I was moved by how inherently Adele seemed to understand the process. But I was hoping that I hadn't gotten myself in deeper than I had imagined. "I sort of have to write by myself," I said.

"I figured that's how most writers do it," Adele said without missing a beat. "I understand. But if you need them, I can give you some tips from time to time. Not that you need me to help you write."

A writer always needs help to write.

Adele hit the button on her talking watch. It was 11:30. We were still ten minutes from the ocean, and Adele was afraid we wouldn't get to the Chateau in time for the lunch lineup. I turned around and headed back.

"I can tell we're back on the freeway," Adele said. "It's noisy."

She held her hand up in front of her like she was off in her own world. I recalled for the first time ever being in my father's '58 Oldsmobile as he drove down Lake Shore Drive. I would sit beside him and hold up my thumb to the sun because it was shining in my face. I was amazed at how my thumb could always cover the entire sun. I never told my father I could do that, because I didn't think he would understand that a little girl could have so much power.

"I can see brighter where the sun is," Adele said.

I asked Adele if she could see her hand.

"No," Adele said.

"But you know it's there."

"Yes. I know it's there."

"I think you just described faith," I said. "You can't see it but you know it's there."

"Absolutely." Adele felt for my hand. "Absolutely. It's there. It's like your book. You just can't see it yet. But believe me. I know. Book is my middle name."

I envied her confidence.

"I'll tell you anything you want to know. After all," Adele said, "I didn't commit any crimes or anything."

"Well, hurry up and do something." I tried to laugh. "It's a jungle out there. I'm probably going to need some good dirt if anybody is going to want to buy this book."

"Now that's using your noodle!" Adele laughed.

Up ahead was the spot where the San Diego Freeway intersected with the 101. I couldn't see it yet, but I knew it was there and that traffic would jam up there and go bumper to bumper because it always did. When that happened, I would have to alleviate Adele's fears that we'd be stuck sitting when the lunch lineup was already forming.

Adele lifted her face to the sun. We were in the middle lane doing sixty with the a/c humming. We cruised straight through. With Adele by my side, everything was going to be all right.

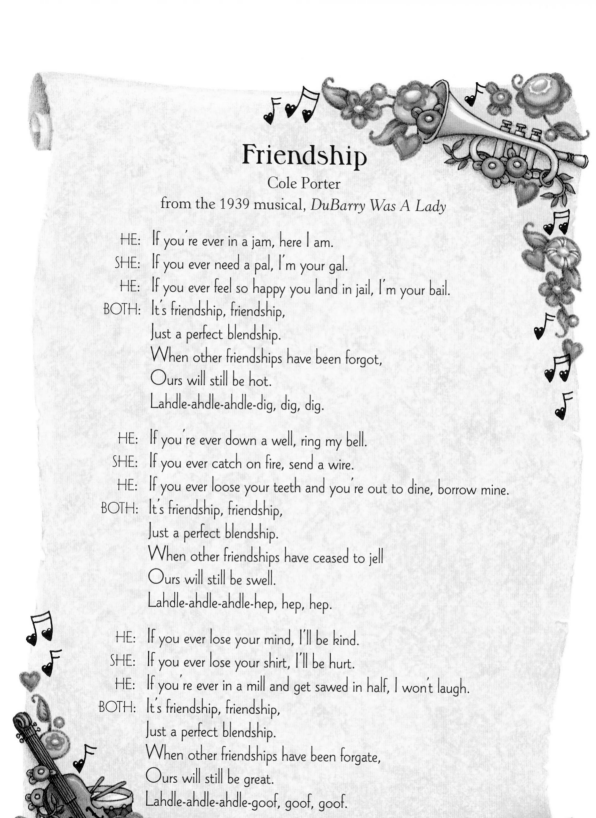

Friendship

Cole Porter

from the 1939 musical, *DuBarry Was A Lady*

HE: If you're ever in a jam, here I am.

SHE: If you ever need a pal, I'm your gal.

HE: If you ever feel so happy you land in jail, I'm your bail.

BOTH: It's friendship, friendship,

Just a perfect blendship.

When other friendships have been forgot,

Ours will still be hot.

Lahdle-ahdle-ahdle-dig, dig, dig.

HE: If you're ever down a well, ring my bell.

SHE: If you ever catch on fire, send a wire.

HE: If you ever loose your teeth and you're out to dine, borrow mine.

BOTH: It's friendship, friendship,

Just a perfect blendship.

When other friendships have ceased to jell

Ours will still be swell.

Lahdle-ahdle-ahdle-hep, hep, hep.

HE: If you ever lose your mind, I'll be kind.

SHE: If you ever lose your shirt, I'll be hurt.

HE: If you're ever in a mill and get sawed in half, I won't laugh.

BOTH: It's friendship, friendship,

Just a perfect blendship.

When other friendships have been forgate,

Ours will still be great.

Lahdle-ahdle-ahdle-goof, goof, goof.

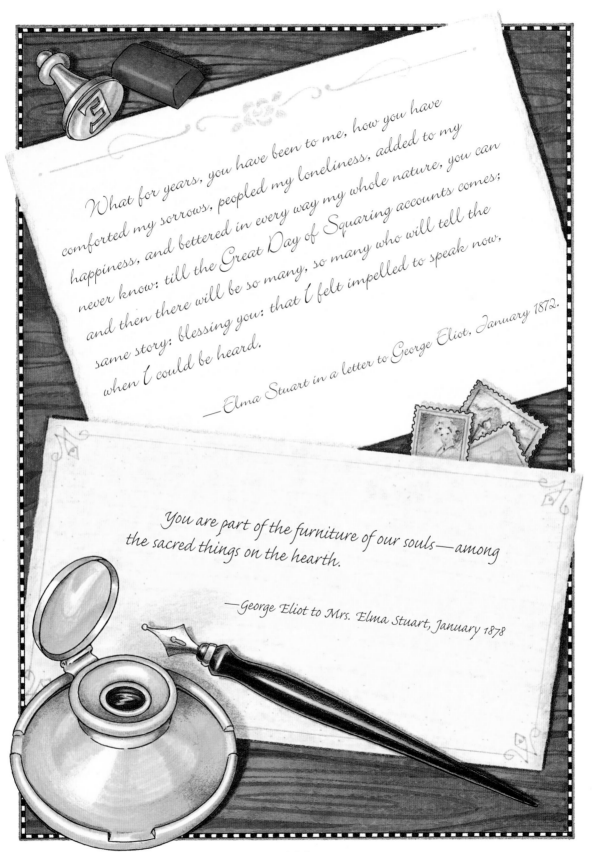

What for years, you have been to me, how you have comforted my sorrows, peopled my loneliness, added to my happiness, and bettered in every way my whole nature, you can never know: till the Great Day of Squaring accounts comes; and then there will be so many, so many who will tell the same story: blessing you: that I felt impelled to speak now, when I could be heard.

—Elma Stuart in a letter to George Eliot, January 1872.

You are part of the furniture of our souls—among the sacred things on the hearth.

—George Eliot to Mrs. Elma Stuart, January 1878

133

A friend is the first
one to come in when the
whole world has gone out.

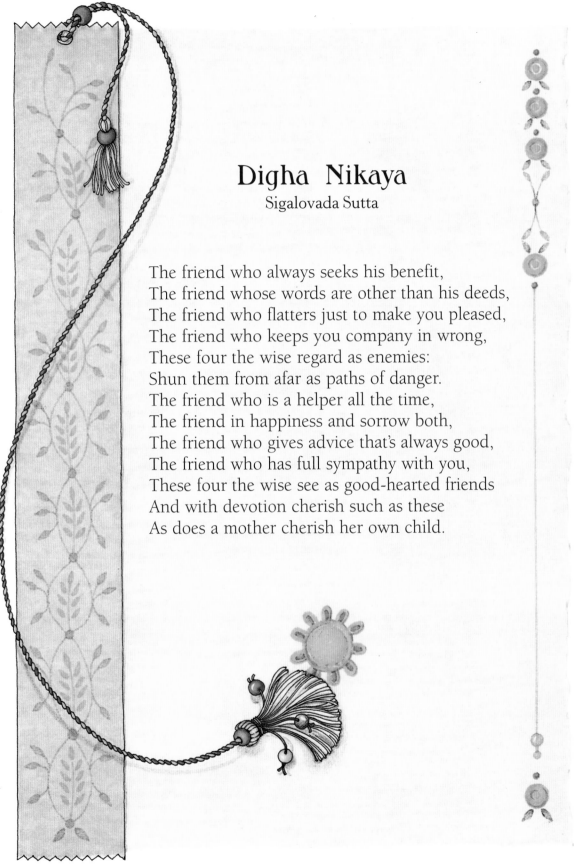

Digha Nikaya
Sigalovada Sutta

The friend who always seeks his benefit,
The friend whose words are other than his deeds,
The friend who flatters just to make you pleased,
The friend who keeps you company in wrong,
These four the wise regard as enemies:
Shun them from afar as paths of danger.
The friend who is a helper all the time,
The friend in happiness and sorrow both,
The friend who gives advice that's always good,
The friend who has full sympathy with you,
These four the wise see as good-hearted friends
And with devotion cherish such as these
As does a mother cherish her own child.

Friendship is unnecessary,
like philosophy, like art...
It has no survival value;
rather it is one of those things
that give value to survival.

—C. S. Lewis

The greatest good you can do for another
is not to just share your riches,
but to reveal to him, his own.

—Benjamin Disraeli

If instead of a gem, or even a flower,
we should cast the gift of a loving thought
into the heart of a friend,
that would be giving as the angels give.

—George Macdonald

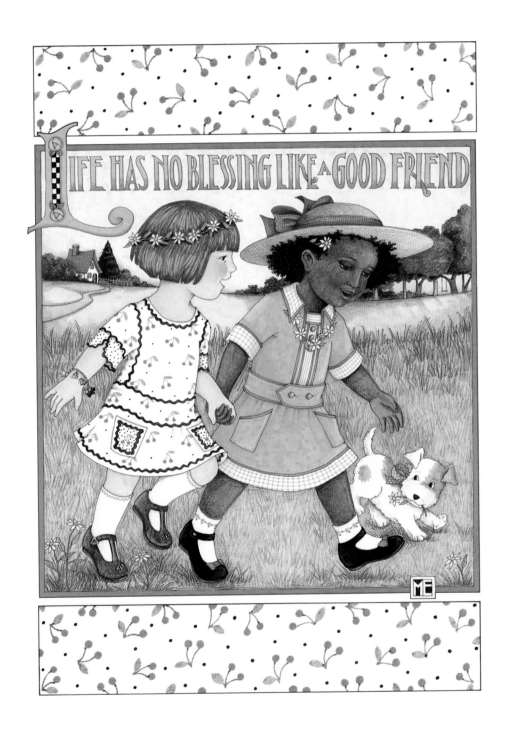

LIFE HAS NO BLESSING LIKE A GOOD FRIEND

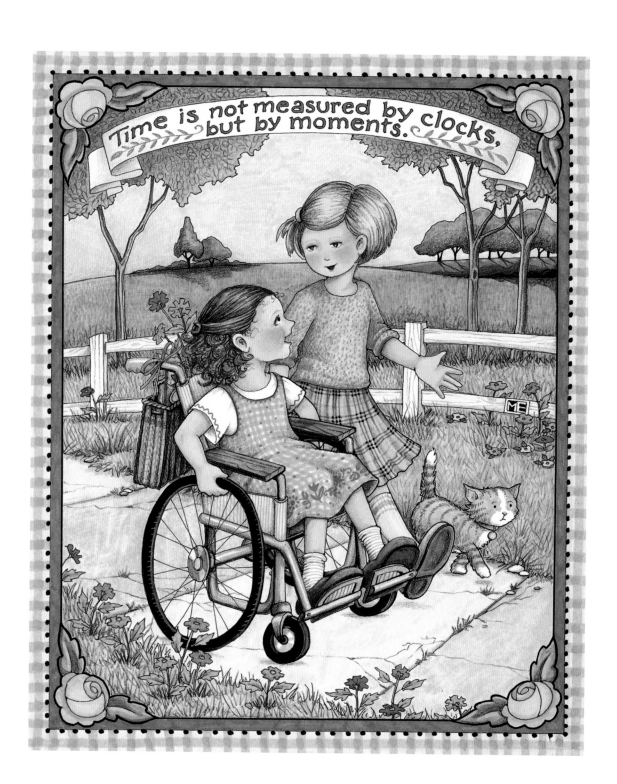

My Neighbor

Joy Belle Burgess

From the beauty of her garden
My neighbor waved to me,
And her joyful notes of greeting
Sang out with melody.

For her words were soft as music
That lingered in my heart;
Her smile a ray of sunlight
That cheered me from the start.

And where her roses blossomed
And embraced her garden wall,
I could not help but tarry,
Becharmed by friendship's call.

Her arms were wide and clutching
The fairest spring bouquet...
A gift of love to please me
And beautify my day.

In the rapture of those moments,
My happiness could flower,
For kindly words were spoken
And affection ruled the hour.

To an Old Friend

Edgar A. Guest

When we have lived our little lives and wandered all their byways through,
When we've seen all that we shall see and finished all that we must do,
When we shall take one backward look off yonder where our journey ends,
I pray that you shall be as glad as I shall be that we are friends.

Time was we started out to find the treasures and the joys of life;
We sought them in the land of gold through many days of bitter strife.
When we were young we yearned for fame; In search of joy we went afar,
Only to learn how very cold and distant all the strangers are.

When we shall meet all we shall meet and know what destiny has planned,
I shall rejoice in that last hour that I have known your friendly hand;
I shall go singing down the way off yonder as my sun descends
As one who's had a happy life, made glorious by the best of friends.

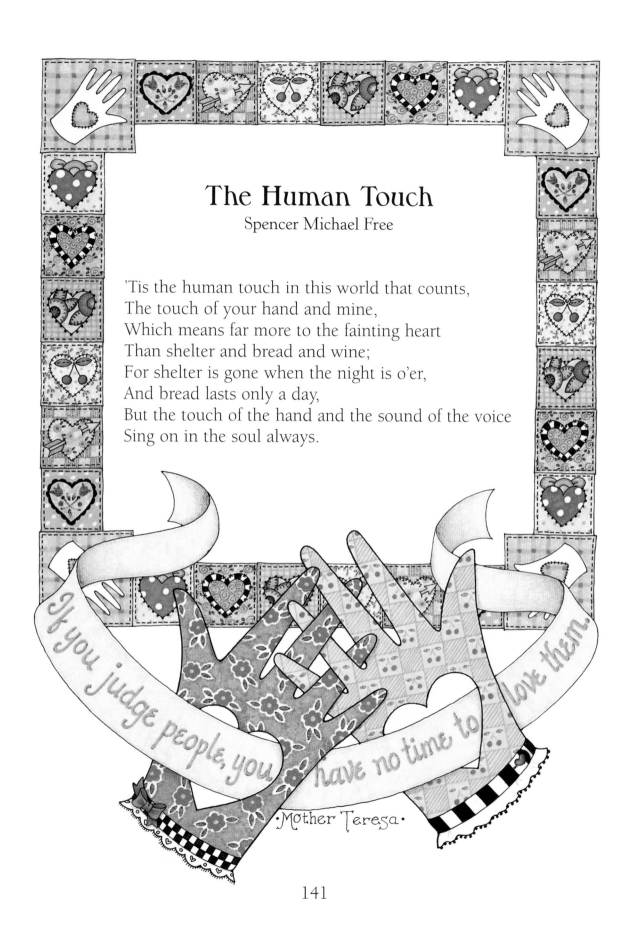

The Human Touch

Spencer Michael Free

'Tis the human touch in this world that counts,
The touch of your hand and mine,
Which means far more to the fainting heart
Than shelter and bread and wine;
For shelter is gone when the night is o'er,
And bread lasts only a day,
But the touch of the hand and the sound of the voice
Sing on in the soul always.

If you judge people, you have no time to love them.

•Mother Teresa•

A friendship can weather most things
and thrive in thin soil—
but it needs a little mulch of letters and phone calls
and small silly presents every so often—
just to save it from drying out completely.
—Pam Brown

They may forget what you said,
but they will never forget how you made them feel.
—Carl W. Buechner

I had three chairs in my house:
one for solitude, two for friendship,
three for society.
—Henry David Thoreau

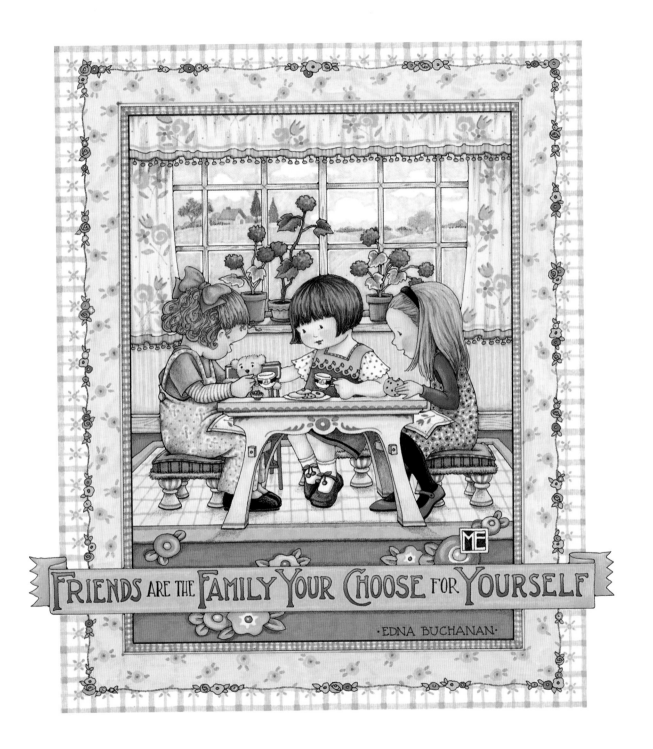

FRIENDS ARE THE FAMILY YOUR CHOOSE FOR YOURSELF

· EDNA BUCHANAN·

Friendly Houses
Elveria Blust

A neighborhood is more than just a place where
 houses stand,
A place where rows of fences neatly separate
 the land.
Here, love for one another can most easily
 be shown,
Where the lamplight in the window means,
 "Come in, you're not alone."
When the families get together and lend a
 helping hand,
Then a neighborhood is more than just a place
 where houses stand.

You've seen the many children grow up quickly
 with the years,
You have known their faults and virtues, and
 still recognize their fears.

When they come back home to visit, they'll
 remember that 'twas here
When as children, in your kitchen, they made
 cookies disappear.

When each family knows a little of each
 others joy and strife,
And they share with one another little
 precious things of life,
Then a neighborhood becomes more than a place
 where houses stand...
It's remembered for its smiles and its
 friendly helping hands.

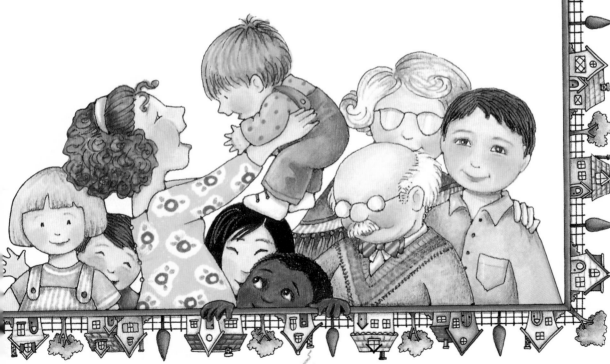

The Company of Women

Anna Quindlen

It was not until my last year in college that students could live in a coeducational dorm. As with the inauguration of any social experiment, there was a fair amount of press coverage and a lot of alarmist talk, mostly about how we would all wind up swinging from the doorjambs naked and giving birth to unwanted triplets.

This could not have been further from the truth. Instead of orgies, the arrangement bred familiarity. Our tiny tubs of yogurt commingled on the windowsills during the winter. And on a few occasions, a member of one or the other sex ignored the elaborate system of signs rigged up for the bathroom doors and some slight shrieking ensued. It was, in some ways, good preparation for marriage, but not in the way our parents feared.

Nevertheless I came away, unfashionable as it was, thinking that there are still times when I prefer the company of women, particularly when I am in pajamas. I have recently returned from a week of female bonding, and remain convinced of this. A friend and I flew south with our children. During the week we spent together I took off my shoes, let down my hair, took apart my psyche, cleaned the pieces, and put them together again in much improved condition. I feel like a car that's just had a tuneup. Only another woman could have acted as the mechanic.

And yet it is still widely assumed that a woman who goes off on a trip with other women missed the booking deadline on something else, or is contemplating divorce and has gone away to think things over. Women

without men are still thought to be treading water. Men without women have broken loose.

There was much general sympathy for my situation, in which my husband and my friend's husband were too embroiled in their work to lie on the beach and chase children around the swimming pool. We tried to cajole them, but to no avail. "I can't believe the two of you are going alone," said a friend, as though we were fourth graders taking the crosstown bus for the first time.

So we went alone, and each night re-created our personal universes. I cooked, she cleaned. I blathered, she analyzed. Neither felt the need to be sociable, or polite: more than once, we picked up our respective books and started to read at opposite ends of the couch. Most of the time we talked and talked, not in a linear way, but as though we were digging for buried treasure. Why did you feel that way? And what did you say then? What are you going to do about that? How long did that go on? It was an extended version of the ladies' lunches in which we bring our psyches out from inside our purses, lay them on the table, and fold them up again after coffee—except that I shuffled around in a T-shirt and underwear, my ensemble of choice.

It wouldn't have been the same if our husbands had been along, and not just because I would have had to put on some decent clothes. The conversation would have been more direct, less introspective, less probing for probing's sake. That's not to say I don't have probing conversations with my husband. But they usually revolve around a specific problem; they are what management consultants call goal-directed, not free-floating attempts to make order out of daily life.

I sometimes think the prototype was a conversation we had about the Miranda decision. What was Miranda's first name? I asked. I can't recall, he answered. Was he married? I don't know. Did he have kids? Why is that important? Where did he live? Who cares? Is he still alive? WHO CARES!

By the time we had finished the conversation we were about as irritated with each other as two people could be. He was oxford cloth, I embroidery. We simply weren't in the same shirt.

My friends who are women are mostly embroidery, too. Perhaps it is a legacy of childhoods in which it was our mothers who explained why flowers die in the fall, why you can sometimes see the moon during the day, and why boys don't ask you to dance. Perhaps it is a legacy of girlhoods in which it was our mothers, with hours to spend with us, who followed their own mothers' leads and talked about this and that and became, if not storytellers of our lives, at least the narrators and analysts.

We were not alone in our female bonding at the beach. The older women did the same, sending their husbands off to the golf course, dishing their daughters-in-law. There have been times when I might have felt sympathy and a slight contempt for these women without men, but those were times when I was young and stupid. Those were times when nearly all my friends were men, after the coeducational dorms and before I was at ease with the femaleness in me.

Those times ended when I got a job at an institution as unequivocally male as a pair of black wingtip shoes. When I arrived I was desperate, not to make friends, but to make female friends. One day I met a young woman at the photocopying machine, and struck up a conversation. We became friends; in fact, she is the friend with whom I took the trip. I still remember the lunch at which we narrated the bare bones of our life stories. We have spent the last ten years filling in the blanks, shading, excavating. She probably knows more about some parts of my life than my husband does: nothing critical, just little bits here and there, some of the tiny dots that, taken together, make up the pointillistic picture of our lives.

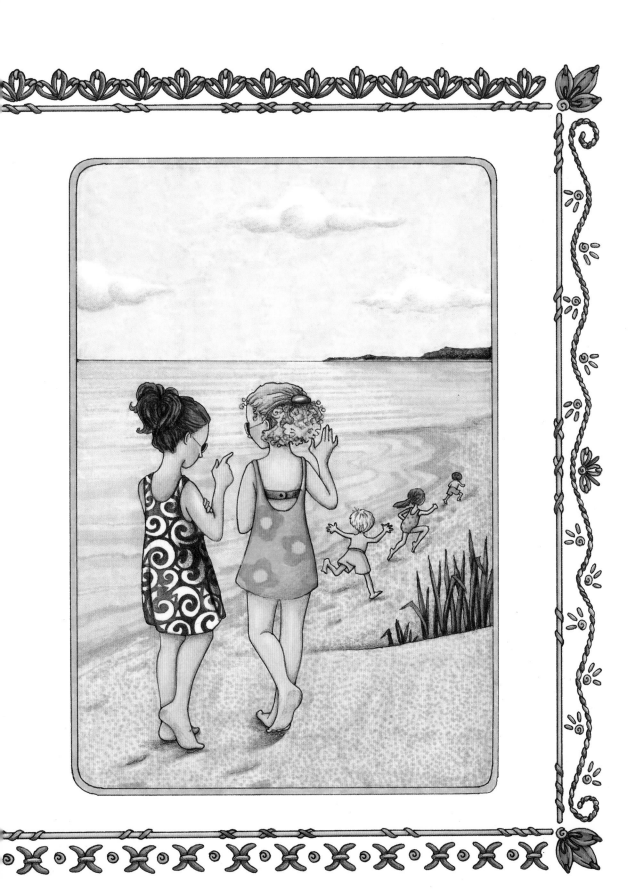

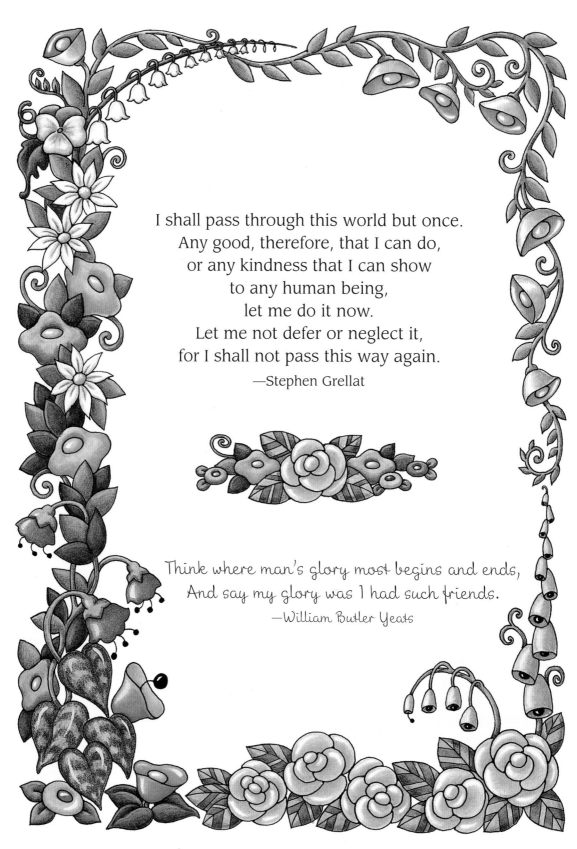

I shall pass through this world but once.
Any good, therefore, that I can do,
or any kindness that I can show
to any human being,
let me do it now.
Let me not defer or neglect it,
for I shall not pass this way again.
—Stephen Grellat

Think where man's glory most begins and ends,
And say my glory was I had such friends.
—William Butler Yeats

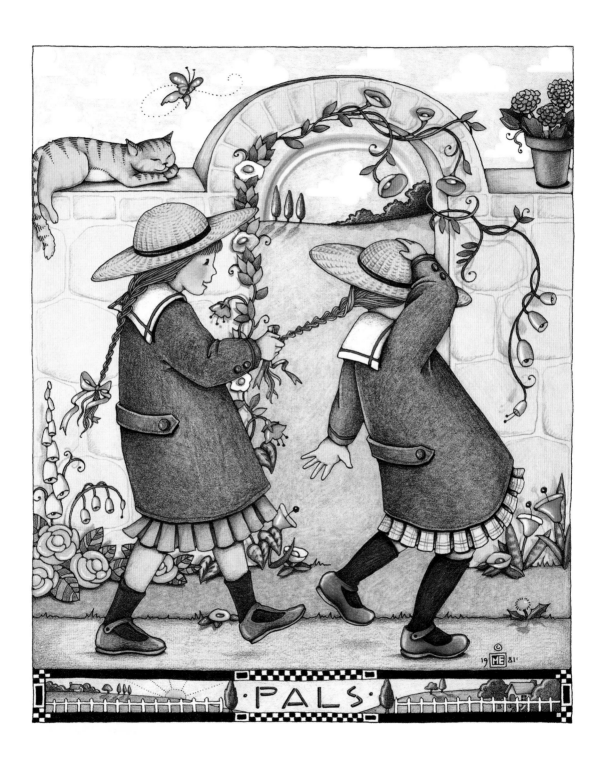

·PALS·

Acknowledgments

Andrews McMeel Publishing has made every effort to contact the copyright holders. The publisher gratefully acknowledges permission to reprint the following selections.

pages 16-17, "All You Need Is a Friend," by Jan Miller Girando. Copyright © 1995 by Mary Engelbreit Ink.

pages 26-29, "Reunion," by Anna Quindlen from *Living Out Loud,* copyright © 1987 by Anna Quindlen. Reprinted by permission of Random House, Inc.

page 34, "Friends," written by Bernie Taupin for Elton John, copyright © 1970 Dick James Music, Limited.

page 39, "Old Times, Old Friends," copyright © Agnes Davenport Bond from *Ideals* magazine.

page 45, "This Is Friendship," by Mary Carolyn Davies. From *Women's History: Poems by Women,* Jone Johnson Lewis, editor. URL: http://womenshistory.about.com/. This poem also appeared in *Don McNeill's Favorite Poems,* published by Don McNeill Enterprises, Inc., Chicago, Illinois, 1951.

page 46, "Getting to Know You," from *The King and I,* music and lyrics by Richard Rodgers and Oscar Hammerstein II, copyright © Williamson Music.

page 55, "The Morning Walk," from *Now We Are Six* by A. A. Milne, illustrated by E. H. Shepard, copyright ©1927 by E. P. Dutton, renewed © 1955 by A. A. Milne. Used by permission of Penguin Putnam Books for Young Readers, a division of Putnam, Inc. All rights reserved.

pages 56-59, "You're the Top," from the 1934 musical *Anything Goes,* words and music by Cole Porter, copyright © 1934. Excerpted from *The Complete Works of Cole Porter,* Robert Kimball, editor, D. A. Capro Press.

pages 62-63, "There Is No Friend Like a Sister," by Jan Miller Girando. Copyright © 1993 by Mary Engelbreit, Ink.

pages 68-73, *Circle of Friends* by Maeve Binchy, copyright © 1991 by Maeve Binchy. Used by permission of Dell Publishing, a division of Random House, Inc.

page 75, "The Friendly Neighbor," by Betty G. Ahearn, copyright © Betty G. Ahearn from *Ideals* magazine.

page 76, "Companioned," by Lee Avery, copyright from *Inland Gulls and Other Poems,* published in The Washington Star, 1955.

page 79, "An American Childhood," by Annie Dillard, copyright © 1987 by Annie Dillard. Reprinted by permission of HarperCollins Publishers Inc.

Author Index

Title Index

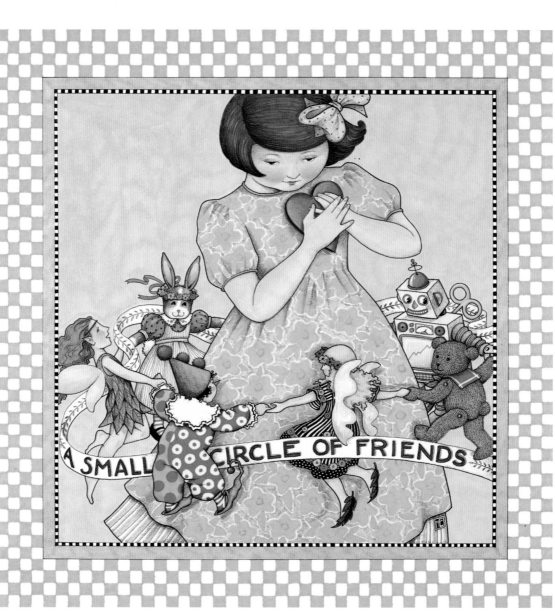

A SMALL CIRCLE OF FRIENDS

Credits

Any book that comes into this world is the result of care and attention of a large group of people. Special thanks to the following, who worked so hard to make this book possible:

Jackie Ahlstrom
David Arnold
Stephanie Barken
Polly Blair
Janice Carter
Delsie Chambon
Pam Dobek
Michelle Dorenkamp
Stephanie Farley
Ann Feldmann
Wende Fink
Casey Frisch
Jennifer Hahn
Becky Kanning
Jean Lowe
Elizabeth Nuelle
Marti Petty
Patrick Regan
Christine Wilkison

To everyone at Mary Engelbreit Studios and Andrews McMeel Publishing, my heartfelt thanks for making this book a reality.